D1116539

Historical American Biographies

THOMAS NAST

Political Cartoonist

Lynda Pflueger

40 Industrial Road PO Box 38
Box 398 Aldershot
Berkeley Heights, NJ 07922 Hants GU12 6BP
USA UK
http://www.enslow.com

*To Deanne Durrett, who always encouraged me, and to
my editor, who helped make this book possible.*

Library of Congress Cataloging-in-Publication Data

Pflueger, Lynda.
 Thomas Nast : political cartoonist / Lynda Pflueger.
 p. cm. — (Historical American biographies)
 Includes bibliographical references and index.
 Summary: Traces the life of the German immigrant whose artistic
talent helped him become a popular and influential political cartoonist.
 ISBN 0-7660-1251-4
 1. Nast, Thomas, 1840–1902—Juvenile literature. 2. Cartoonists—
United States—Biography—Juvenile literature. [1. Nast, Thomas,
1840–1902. 2. Cartoonists.] I. Title. II. Series.

 NC1429.N3 P39 2000
 741.5'092—dc21
 [B]
 99-043631

Printed in the United States of America

10 9 8 7 6 5 4 3 2

To Our Readers: We have done our best to make sure all Internet addresses in this book were active and appropriate when we went to press. However, the author and the publisher have no control over and assume no liability for the material available on those Internet sites or on other Web sites they may link to. Any comments or suggestions can be sent by e-mail to comments@enslow.com or to the address on the back cover.

Illustration Credits: Enslow Publishers, Inc., pp. 16, 27, 34, 59; From the Collection of Macculloch Hall Historical Museum, pp. 23, 44, 69, 105; Library of Congress, pp. 1, 7, 25, 31, 37, 41, 54, 72, 75, 80, 82, 89, 99, 101, 109, 113; National Archives and Records Administration, pp. 47, 63, 64, 67, 86; Reproduced from the *Dictionary of American Portraits*, Published by Dover Publications, Inc., in 1967, pp. 4, 9, 52, 73.

Cover Illustration: Library of Congress (Inset—Thomas Nast); Library of Congress (Background—Nast's cartoon *No Rest for the Wicked—Sentenced to More Hard Labor*).

CONTENTS

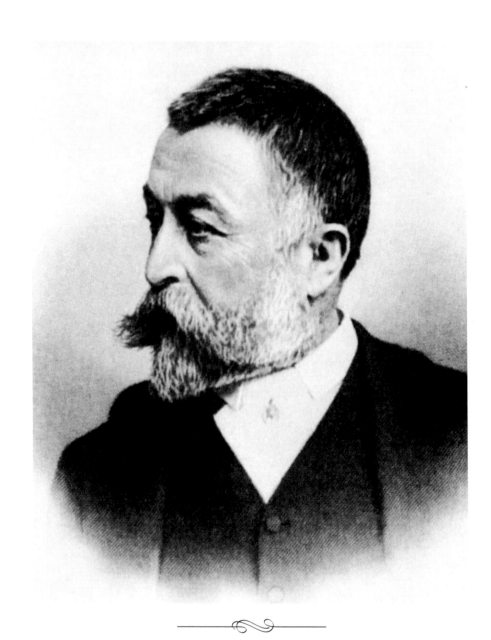

Thomas Nast

1

THE CRUSADE

After the Civil War, New York City's streets were crowded with horsecars, stagecoaches, carriages, wagons, and people. During peak hours, it was dangerous for a pedestrian to try to cross the street. Pollution was a serious problem. More than one hundred thousand horses worked on the city streets, and they filled the streets with manure.[1] People threw garbage out their windows and burned coal to heat their houses and businesses, which constantly sent black fumes into the air.

The city's population was growing at a tremendous rate. Hundreds of immigrants, mostly from Ireland and Germany, arrived in the city each month.

Business was booming and nearly three fourths of the nation's imports passed through the New York City harbor. The city's government was overwhelmed and could not keep pace with the changes.

William Marcy Tweed, a charming but corrupt politician, took advantage of this situation and built himself a political empire. Tweed had a knack for making friends. In a short time, he became the leader of the Democratic party and, with the help of three of his associates, formed the "Tweed Ring" and took over the city's government.

The Tweed Ring's primary source of power came from awarding citizenship to immigrants by the hundreds and bribing them with jobs and favors in exchange for their votes. The ring also made fortunes by permitting overcharging on city construction projects. Contractors kicked back to ring members 65 percent of what they charged. If a contractor could do a job for thirty thousand dollars, he would charge the city one hundred thousand dollars and pay the Tweed Ring sixty-five thousand dollars for the privilege of doing the job. Many New Yorkers were concerned about the operations of the Tweed Ring, but no solid proof of the ring's activities existed.

Thomas Nast, a political cartoonist working for *Harper's Weekly*, took it upon himself to harass the Tweed Ring continually with his drawings in an attempt to bring the ring down. During his crusade, Nast often focused his attention on Tweed. In one drawing, Nast drew Tweed dressed in a three-piece

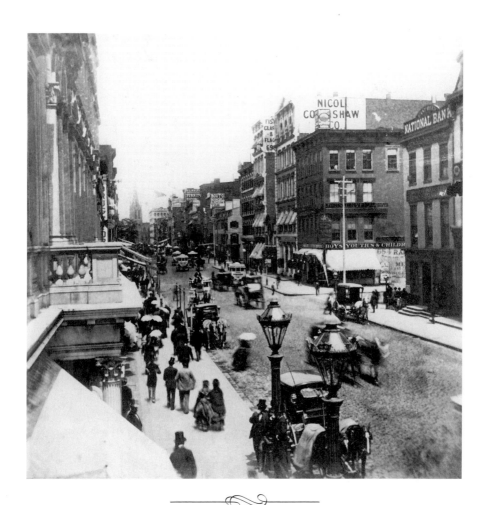

New York City in the mid-nineteenth century was already a bustling, crowded place to live.

business suit and replaced his head with a moneybag to signify the money he had stolen from the city. The cartoon was entitled *Brains*, and in the caption underneath the drawing, Nast quoted Tweed as saying, "Well, what are you going to do about it?"[2]

In time, the attention Nast focused on Tweed unnerved the ring's political boss. Tweed demanded that the pictures be stopped. He did not care what the papers said about him. He knew his constituents could not read. "But they can't help seeing them damned pictures," Tweed remarked.[3]

In 1871, the Tweed Ring tried to intimidate Nast and then to bribe him. One day, an officer from the Broadway Bank, where the Tweed Ring kept its funds, came to visit Nast at his home. The banker

Election of 1868

In 1868, the Tweed Ring ran what was probably the most crooked election in New York City's history. Six weeks before the election, the ring began an extensive campaign to award citizenship and voting privileges to as many new immigrants as they could find. The campaign netted 41,112 new voters.[4] Many of these new voters were illegally registered in several sections of the city and proceeded to cast their votes repeatedly. The repeaters received five dollars for each vote they cast, and they each voted an average of nine times. Consequently, nearly "8 per cent more votes were cast than the entire voting population of the city."[5]

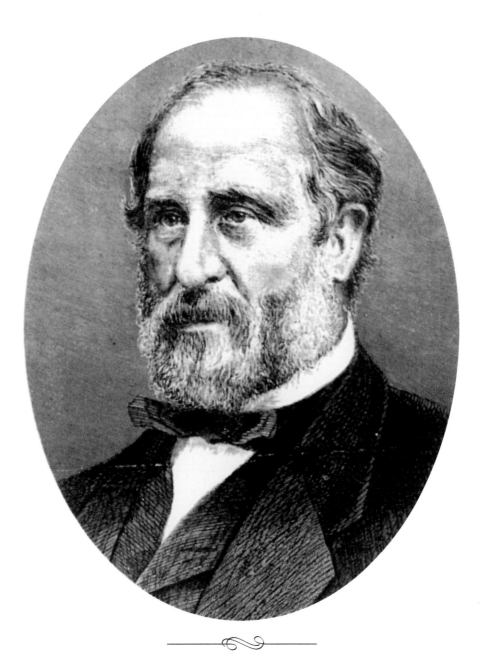

*As the political boss of New York City, William Marcy "Boss" Tweed
was a powerful enemy to Thomas Nast.*

told Nast that a group of wealthy men, who admired Nast's work, wanted to send him to Europe to study art. He told Nast that they would pay him one hundred thousand dollars if he would go. Nast was suspicious and asked if they would raise the fee to two hundred thousand dollars. The banker said yes and added, "You need study and you need rest. Besides this Ring business will get you into trouble. They own all the judges and jurors and can get you locked up for libel. My advice is to take the money and get away."[6]

Nast, convinced that the Tweed Ring was trying to bribe him, asked his visitor if he thought he "could get five hundred thousand dollars to make that trip?"

The banker replied without hesitating, "You can get five hundred thousand dollars in gold to drop this Ring business and get out of the country."

"Well, I don't think I'll do it," replied Nast. "I made up my mind long ago to put some of those fellows behind bars, and I'm going to put them there."[7]

YOUNG ARTIST

On September 27, 1840, Thomas Nast was born in a military barracks in Landau, Germany. He was the fourth child and only surviving son of Appolonia Abriss and Joseph Nast.[1] His father played the trombone in the 9th Regiment Bavarian Band.

Children did not usually live in the military barracks in Landau. Young Thomas became a favorite of the soldiers. They made excuses to visit him, and when he was old enough, they played soldiers with him in the field behind the barracks. One day, the barracks commander told Thomas's proud mother that her son would one day grow up to be a captain.

Thomas's first art project was making toy soldiers out of beeswax. The beeswax probably came from his mother's sewing basket. He pressed his little soldiers against the windowpanes of his home to display them. Ladies living nearby were so impressed with his creations that they rewarded him with cookies.

In 1845, times were bad in Europe, and a revolution was brewing in Germany. The majority of the population was made up of farmers. Several years of poor harvests had led to an economic depression and a great deal of unrest. Some German reformers wanted a less powerful monarchy and the right to vote for the public officials who represented them.

Joseph Nast was an outspoken advocate for change in his homeland. One day, a friendly commander advised him that America would be the best place for him to go, because he was so fond of speaking freely. Following his commander's advice, he sent his family ahead to America. When his enlistment in the army was over, he planned to join his family in New York City.

New York City

During the summer of 1846, Thomas, his mother, and his older sister arrived in New York City. They settled in a house on Greenwich Street. Shortly after they arrived, Thomas's mother enrolled him in a nearby school. He could not speak a word of English, and his classmates played a dirty trick on him. They

told him to stand in the punishment line, where students waited to be spanked by the principal for breaking the school rules. After his encounter with the principal, he went home and refused to return.

A short time later, the Nast family moved into a quiet neighborhood on William Street. Next door lived an artist who made crayon sticks. The artist was impressed with Thomas's drawings and gave him the faulty crayons he could not sell.

After they moved, Thomas's mother enrolled him in a school where German was spoken. At his new school, Thomas drew a picture of a lion being hunted that impressed his fellow classmates. One of them showed it to their teacher. Thomas was afraid of being punished for drawing in class, but instead his teacher praised his work.

The only problem Thomas encountered at his new school was a bully who picked on him every day at playtime. Thomas suffered in silence until he finally had enough. Suddenly, he turned on his tormentor with such a fury, the bully had to be rescued by a teacher. This made Thomas a hero in the eyes of his classmates.

Thomas continued to draw "anything and everything."[2] His desk at school was full of his drawings, and the walls of his house were lined with them. One Sunday, his enthusiasm for art almost led to his arrest. While his mother was in church, he found a beautiful picture of a ship on the wall of a building near his home. He wanted to draw the ship, so he

Chasing Fire Engines

In New York City, a favorite pastime for boys was chasing fire engines. Fires were almost a daily event in a city where wooden buildings were heated and lighted by burning wood, gas, and kerosene. Volunteer fire companies fought the blazes. One of the most popular companies, the Big Six, had a tiger's head painted on its fire engine. William M. Tweed was the chief of the "Big Six." Tweed's fire company eventually nominated him for public office, which launched his political career.

took out his pocketknife and began to cut the picture off the wall. Before he was done, a policeman came up behind him and grabbed him. Thomas yelled so loud that the startled policeman dropped him. Thomas's landlord appeared and vouched for him. Luckily, the policeman let Thomas go with just a lecture.

In 1850, when Thomas was ten years old, his father finally joined his family in New York City. On the day his father was expected to arrive, Thomas went to the corner bakery to buy a German coffeecake for his mother. As he was returning from the bakery, a cab passed him and then stopped. Suddenly, a man leaped out, grabbed him, and pulled him inside the cab. At first, Thomas thought he had been kidnapped. Then he recognized his father, who hugged him so hard that the coffeecake he had just bought was crushed between them.

A skilled musician, Joseph Nast joined the Philharmonic Society and found a job playing in the orchestra of a New York theater. He often allowed his son to carry his trombone to the theater and stay to watch the show. Thomas sat in a special chair in the back of the orchestra pit and sketched the scenes he saw on the stage.

Thomas's father also took him to see famous people who came to New York City. In 1851, Louis Kossuth, a hero from the Hungarian revolution, was greeted by thousands of New Yorkers. Thomas and his father watched a parade held in Kossuth's honor. Afterward, Thomas drew pictures of Kossuth. One of the pictures, with a rising sun in the background labeled *Hungry*, impressed Thomas's teachers. His picture was framed and hung in a prominent place near the principal's desk.

Art School

Thomas was not a good student. The only thing he wanted to do was draw. When he attended the Forty-seventh Street Academy, one of his teachers told him to go finish his pictures because he would never learn to read or do arithmetic. Thomas's family tried to encourage him to do better in school. His father hoped Thomas would follow in his footsteps and become a musician. Finally, he gave up and enrolled his son in art school.

For a while in 1854, Thomas attended drawing classes taught by Theodore Kaufmann, a German

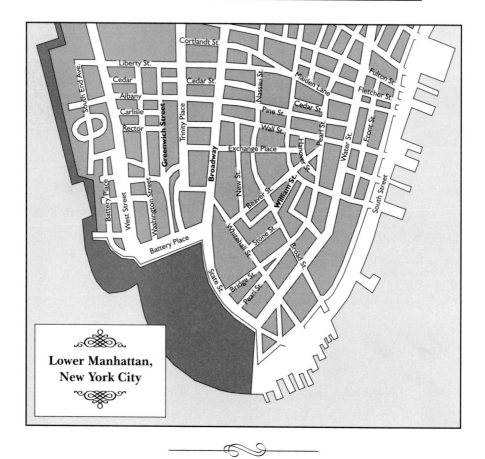

Lower Manhattan, New York City

This map shows the area in lower Manhattan, New York City, where Thomas Nast grew up.

painter of historical scenes. Kaufmann's studio was located at 442 Broadway in the same building where several other well-known artists worked. Thomas developed a close friendship with one of the artists, Alfred Fredericks. In 1855, after a fire destroyed Kaufmann's studio, Fredericks helped Thomas obtain admission to the National Academy of

Design in New York City, where Fredericks was an instructor.

In 1856, when Thomas was fifteen years old, his family could no longer afford to send him to art school. It was time for him to go to work and support himself. One day, he gathered up some of his drawings and went to see Frank Leslie, the publisher of *Frank Leslie's Illustrated Newspaper*, to ask for a job. Leslie's sixteen-page newspaper was published weekly. It sold for ten cents a copy. At the time, photographs could not be mass-produced, so newspapers and magazines were illustrated with drawings engraved on blocks of wood.

"So you want to draw pictures for my paper?" Leslie asked.[3] When Thomas nodded, Leslie told him to go down on Sunday morning and watch the people boarding the ferry. Then he should make a picture of the crowd for Leslie "at the last call of 'All Aboard!'" Leslie was sure the job would be too much for the young lad.[4]

Thomas accepted the assignment. He arrived at the docks early and stayed late drawing his picture. The following Monday morning, he returned to Leslie's office and showed him the drawing.

"Do that alone?" Leslie asked him.[5]

Thomas replied that he had. Leslie then handed Thomas a block of wood and instructed him to go upstairs, where one of the staff artists would help him prepare the block for engraving. Upstairs, Thomas was told to redraw his picture in reverse on

the block of wood. Then he was shown how to gouge out the wood surrounding his drawing. When he was done, only the raised lines of his drawing were standing above the rest, ready to be printed. After seeing his work, Leslie hired Nast at a starting salary of four dollars a week. Nast's career as an artist had begun.

3

LEARNING HIS TRADE

While working for Leslie's newspaper, Thomas Nast developed a special relationship with John Davis, one of America's leading wood engravers.[1] Seventeen-year-old Nast often enjoyed visiting the Davis family. Davis occasionally visited the Nast home, where he found the walls of Nast's room covered with his drawings and his closet drawers filled with even more of them. Davis once commented that he "was surprised by the boy's industry."[2]

Nast's industriousness was prompted by his desire to learn, but also because his father had died shortly after Nast joined the staff of *Frank Leslie's Illustrated Newspaper*. Nast not only needed to

support himself, but also to help support his mother. Often he would get up at four in the morning to practice his drawing and would work until late in the night on his assignments.

While working for Leslie, Nast had his first opportunity to fight political corruption. Several dishonest dairymen were feeding their cows inferior food called slop and were keeping their animals in filthy barnyard stalls. The animals became ill, but the dairymen continued to milk them and sell the milk to the public. City officials were in league with the dairymen. Leslie sent his artists out into the field to draw the diseased cows in their miserable conditions. The dairymen threatened Leslie's life. Leslie did not give up. Eventually, he won. The dairymen were forced to clean up their act.

In 1859, Leslie encountered financial problems and had to reduce the staff on his newspaper. After Leslie let him go, Nast started to do freelance work. *Harper's Weekly*, a new periodical, published a full-page drawing of Nast's, exposing a police scandal on March 19, 1859. He also sold his drawings attacking New York gambling houses to the *Sunday Courier*. In addition, he contributed drawings to the *Comic Monthly* and the *Yankee Notions*—two popular papers of the day that were highly illustrated.

The Edwards Family

During the summer of 1859, J. G. Haney, the publisher of the *Comic Monthly*, introduced Nast to the

Edwards family and their circle of friends. The Edwardses' home was a favorite meeting place for many young and gifted members of New York's artistic and theatrical community. The group took a liking to Nast, nicknaming him Roly-poly because of his slight stature and broad frame. They asked him to help with the preparations for their Fourth of July picnic and even wrote a poem about him:

> *The young artist friend who*
> *along with us came,*
> *And rushing along on the*
> *turnpikes of fame.*[3]

Nast fell in love with one of the Edwardses' daughters, Sarah, and began to court her.

At Christmastime, the Edwards family and their friends put together a Christmas production. Nast was listed on the program for the affair as the "Scenic Artist in Chief." He also played the part of Bibbobobo-bubble, a valet and barber, in the show. Nast had a rich musical voice, and during the performance, he gave a spontaneous impersonation of a popular and fat Italian opera singer that "brought down the house."[4]

New York Illustrated News

In November 1859, Nast went to work for the *New York Illustrated News*. They paid him forty dollars a week, which was more than he had ever earned. He was assigned to cover the funeral of abolitionist John Brown. Then he did a series of anticorruption

New York City Tenements
New York City was in the middle of a housing crisis because of the arrival of a large number of European immigrants. Many landlords capitalized on the problem by turning three- or four-story single-family homes into dwellings that would accommodate two families on a floor. This led to severe overcrowding and unsanitary health conditions. An area filled with tenement houses on the Lower East Side of the city, called the Seventh Ward, had the highest rate of disease in the whole city. Another section, the Tenth Ward, was called the suicide ward by the Bureau of Vital Statistics, because so many people took their own lives due to their horrible living conditions.

drawings exposing the misery of living in New York tenements.

Europe

Shortly after joining the staff of the *New York Illustrated News*, Nast was given the opportunity to travel to England to cover the heavyweight prizefight between American John Heenan and the English champion, Thomas Sayers. Heenan weighed 210 pounds and Sayers weighed 156 pounds. America and England were not on the best of terms at the time, and the fight was to be a contest to see who was the strongest—the American or the Englishman.

The upcoming fight was talked about in both countries. "Never in the history of nations has there

been a sporting event that even approached it in public importance," one commentator reported on the event.[5]

Before Nast sailed for London, he evidently proposed to Sarah Edwards, who replied that she needed time to think about his proposal. Nast sailed on February 15, 1860, aboard the S.S. *City of Manchester*. Before the ship arrived in London, it made a stop in Glasgow, Scotland. From Glasgow, Nast wrote to Sarah Edwards, whom he affectionately called Sallie: "I wish you were with me so you could see this romantic country. There is a Cathedral in Glasgow that was founded . . . in the year 1123. Do you not wish you could see this 'Old Gothic Church'? I took two sketches of it."[6]

When Nast arrived in London, he visited both boxers' training camps. He developed a special friendship with Heenan. The American had to move his training camp three times in eight weeks in order to avoid the English police, who

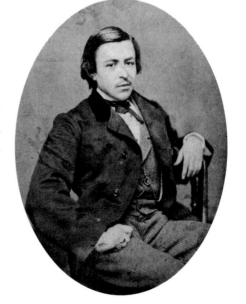

In 1860, Thomas Nast traveled to England to cover the prizefight between John Heenan and Thomas Sayers.

were harassing him. Finally, he set up his camp in a place called Trent Lock, which was located at the edge of three counties. From this location, Heenan could quickly escape from one county to the other in order to avoid the police.

The fight took place on April 17, 1860, and lasted forty-seven rounds before police broke it up and declared the fight "a drawn battle."[7] The _New York Illustrated News_ called Nast "our special artist" and devoted an entire issue to his pictorial reports of the prizefight.[8] They also neglected to pay him.

Nast confided in his new friend, John Heenan, that he was broke. "We'll fix that," Heenan told him.[9] Heenan borrowed twenty pounds (English money) and loaned it to Nast. In return, Nast gave him a note to present to the _New York Illustrated News_. In the note, Nast requested that the newspaper pay Heenan one hundred dollars out of the back wages they owed him. Nast also gave Heenan a second note requesting that his mother repay Heenan if the newspaper would not honor his first note. Heenan tore up the note requesting payment from Nast's mother and told Nast not to worry. He would make the newspaper pay him.

War Correspondent

From England, Nast went to Italy to cover Giuseppe Garibaldi's fight to free his native Italy from Austrian and Spanish domination. In June 1860, Nast left London for Genoa, Italy. From Genoa, he

wrote Sarah Edwards to tell her: "My name is now in public." Then he added: "I will do justice to it (that is to say if I can)."[10]

From Genoa, Nast went to Palermo, Sicily, where he and a shipload of volunteer soldiers were greeted by Garibaldi on June 17. Five days later, he wrote to Sarah and told her about the "great deal of danger" he had traveled through to reach Garibaldi in Palermo.[11] He also told her that he longed for her and that she should not worry about him. Then he added: "I have come here to make a name, to please you by that name, so you will love me. . . ."[12]

In Palermo, Nast adopted the dress of Garibaldi's soldiers—a red shirt and gray pants. He also began to carry a long knife attached to his belt and acquired a hat similar to the one Garibaldi wore.[13] Nast witnessed the horrors of war in Palermo and sketched the ruins of the city.

From Palermo, Nast went to Milazzo. The Spanish military forces

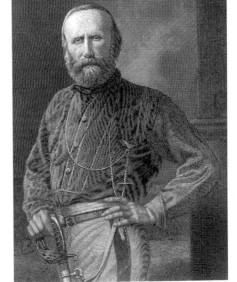

Giuseppe Garibaldi (seen here) fought to free Italy from Austrian and Spanish domination. Nast traveled to Italy to cover Garibaldi's battle.

Red Shirts

Exiled from his homeland, Giuseppe Garibaldi, the son of an Italian fisherman, lived on Staten Island in New York in the early 1850s and worked in a candle factory. While living in New York, Garibaldi liked the red shirts worn by New York City's volunteer firemen and decided to adopt them as part of his army's uniform.

in Milazzo surrendered to Garibaldi on July 25, 1860. Nast's Italian sketches were published in the *Illustrated London News* and the *New York Illustrated News*.

In September, Nast covered Garibaldi's triumphant entry into Naples, where Garibaldi handed his army over to King Victor Emmanuel and proclaimed him the king of United Italy. Then Garibaldi left Naples and sailed to his home in Caprera, a small island off the coast of Sardinia.

From Naples, Nast continued to travel through Italy. He went to Rome, Florence, Milan, and Genoa. Then he visited Switzerland and Germany, where he went to his former home in Landau and visited Nabburg, his father's birthplace.[14] He returned to the United States on February 1, 1861, with only a dollar and a half left in his pocket.[15] Sarah Edwards was waiting for him. In a short time, they became engaged.

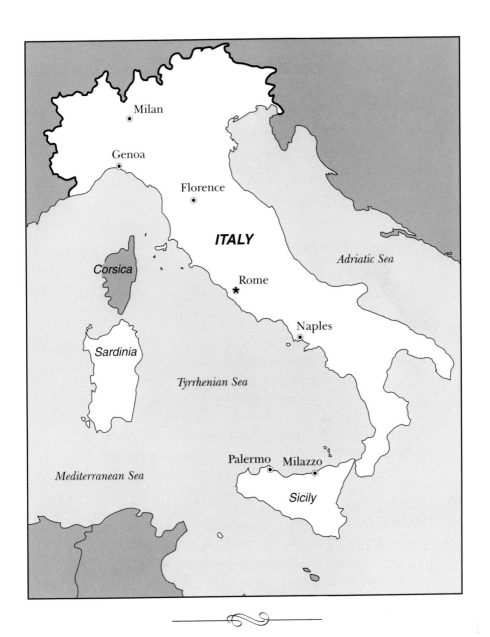

Thomas Nast traveled through Italy, covering the fight to free the
nation from Austrian and Spanish rule.

Troubled Times at Home

While Nast was in Europe, tensions over slavery and sectional differences between the Northern and Southern United States were leading the nation to war. The last straw in the conflict was the election of Abraham Lincoln as president in 1860. Shortly after Lincoln's election, several Southern states seceded from the Union and formed their own government, the Confederate States of America. Nast was a strong supporter of the Union and opposed slavery. He would express his views strongly over the coming years.

Slavery and the Cotton Gin

In the Northern United States, slavery was no longer common by the mid-nineteenth century because cheap labor was provided by the large number of European immigrants who came each year. In the South, slavery flourished with the invention of the cotton gin. Developed by a Northern teacher, Eli Whitney, this simple device permitted a slave to produce three hundred to one thousand pounds of cotton per day.[16] Without the cotton gin, a slave could only produce one pound of cotton a day. The demand for cotton soared over the years, and the South's economy became dependent on slavery, which led to strong disagreement between the North and the South.

4

CIVIL WAR ARTIST

When Nast returned home, he resumed working
for the *New York Illustrated News*, although
it continued to owe him money. On February 19,
1861, he covered President-elect Abraham Lincoln's
reception in New York City. The enthusiastic crowd
almost overwhelmed the future president. Lincoln's
coat was torn and his hair mussed. Nast drew several
sketches of the future president and noted that he
wore a beard and did not look anything like the pre-
vious sketches Nast had seen of him.

Later in the month, Nast's newspaper sent him
to Philadelphia and to Washington, D.C., to cover
Lincoln's inaugural trip to the capital. After giving
speeches and raising the flag over Independence

Lincoln's Beard

Grace Bedell, an eleven-year-old girl living in Westfield, New York, wrote to Abraham Lincoln before the election of 1860 and suggested that he grow a beard. She thought he would "look a great deal better" with a beard because his face was "so thin."[1] She also added that "All the ladies like whiskers and they would tease their husbands" into voting for him.[2] Lincoln took Grace's advice and was the first president of the United States to wear a beard.

Hall in Philadelphia, Lincoln planned to stop in Baltimore, Maryland, on his way to Washington, D.C. Lincoln was extremely unpopular with Southerners, who feared he would abolish slavery. When a plot was uncovered to assassinate Lincoln, he was persuaded to switch trains and travel secretly through the city at night. When his train passed through Baltimore, Lincoln was hidden in a sleeping berth. At dawn the following morning, his train arrived in Washington, D.C., unannounced.[3]

Nast went to Baltimore, but when it became apparent that Lincoln was not there, he went on to Washington, D.C. He stayed in the Willard Hotel, where Lincoln's headquarters was located. The hotel was filled with politicians and dozens of people seeking appointments to government jobs. Nast made several sketches of the people he saw and of the events that led up to the inauguration.

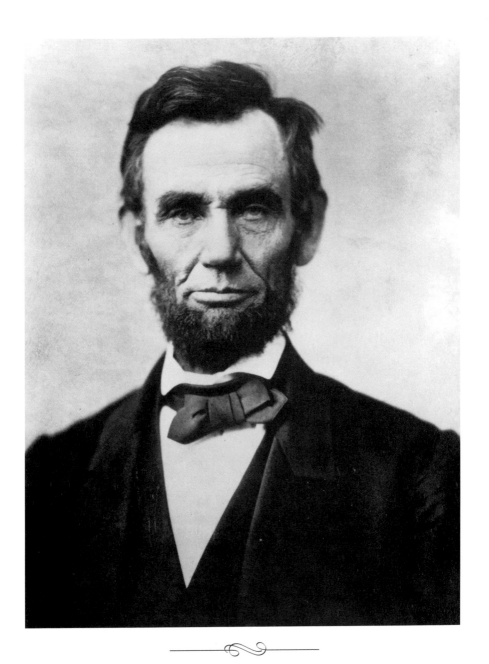

Nast was a strong supporter of President Abraham Lincoln.

Washington, D.C., looked like an armed military camp on March 4, 1861, Inauguration Day. There were rumors of more assassination plots against Lincoln and of Southern plans to take over the capital and prevent the inauguration. Due to the rumors, soldiers lined the parade route as outgoing President James Buchanan and President-elect Lincoln rode down Pennsylvania Avenue. Army sharpshooters concealed themselves on rooftops above the street. At the unfinished Capitol, where the new president was to be sworn in, soldiers surrounded the building and plainclothes detectives mingled with the crowd. The army even posted a line of short cannons on the hill overlooking the Capitol. Artillerymen manned the guns and watched for trouble.

Everyone waited in anticipation for the ceremonies to end and sighed with relief when no violent incidents occurred. The atmosphere had been so intense that Nast felt a shout from the crowd or a single shot in the distance would have "inflamed the mob."[4]

That evening, in his room at the Willard Hotel, Nast was attempting to make sketches of what he had seen during the day. He picked up his pencils and set them down a dozen times. Then he got up and walked the floor. His head was throbbing and he sat down and pressed his hands to his temples.[5] Suddenly, in the house across the street, a man stepped out on the balcony and "in a rich, powerful

voice" began to sing "The Star-Spangled Banner." Then "A multitude of voices" joined in, and when the song was over, "the street rang with cheers."[6] The tension was broken, and Nast believed that an unknown man who had the courage "to sing that grand old song of songs" had saved the capital from despair.[7]

War and a Wedding

In April 1861, Fort Sumter, a Union facility on South Carolina soil, was fired upon and eventually seized by Confederate soldiers. After the fall of Fort Sumter, Lincoln issued a call for seventy-five thousand volunteers to serve for ninety days in the United States Army and bring the rebellious Southern states back into the Union.

The first major battle of the Civil War occurred four months after Lincoln's inauguration, beside a small stream called Bull Run near Manassas Junction, Virginia. The confrontation began on July 18, when the Union Army, made up of thirty-seven thousand volunteers, crossed the Potomac River and began its march into Virginia. The Union goal was to destroy the railroad at Manassas Junction and then move on to capture Richmond, the capital of the new Confederacy. The Confederate Army, thanks to information gained from a spy, knew the Union forces were coming. To block the invasion, they sent troops north to form an eight-mile line along Bull

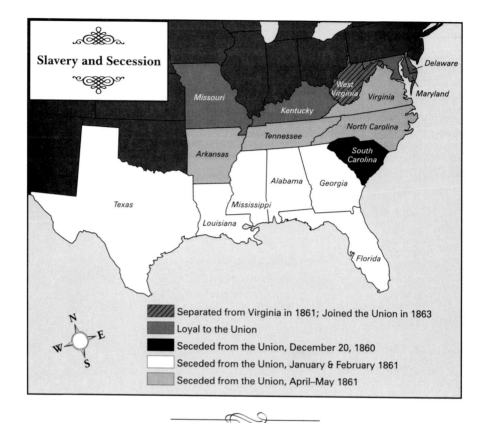

Seven Southern states seceded from the Union in response to Abraham Lincoln's election as president. After the firing on Fort Sumter, four more states would secede, bringing the number of Confederate states to eleven.

Run. When the armies collided, the battle ended in a Southern victory.

Two months after the Battle of Bull Run, Nast married Sarah Edwards on September 27, 1861, his twenty-first birthday. Sarah was twenty years old. Because of the war, the day had been declared a day of prayer. The young couple chose to be married in

the early morning so that their wedding would not conflict with public services. After the ceremony, they breakfasted with family members and friends and then boarded a train for Niagara Falls, where they honeymooned.

After his marriage, Nast considered joining the Union Army. His friends and family discouraged him. They told him his pen was a better weapon than a sword.

Illustrators Needed

When it became clear that the war would not end in three months, as had previously been anticipated, illustrators were in great demand. In the spring of 1862, Frank Leslie offered Nast fifty dollars a week to come back to work for him. Nast was the only artist at the time who had battlefield experience because of the time he spent in Italy. He knew what a battle looked like, how soldiers behaved under fire, and the horrors of the battlefield.[8] Nast accepted the position. In a short time, because of Leslie's poor financial situation, Nast's salary dropped to thirty dollars per week. Then Leslie let him go.

For several months, Nast freelanced. Some of his drawings were published in *Harper's Weekly*, a new publication founded by four brothers in 1857. The new periodical paid well and on time. The following summer, Nast became a regular staff member at *Harper's Weekly*. Fletcher Harper, one of the brothers who owned *Harper's Weekly*, took a special

interest in his new "industrious and capable young artist."[9] Previously, Nast drew sketches that illustrated news articles. At *Harper's Weekly*, he was permitted to draw pictures that stood on their own and needed no article to accompany them.

Nast disliked working in the art room at *Harper's* and in a short time was allowed to do his drawings at home. While he worked, his wife read to him. On July 1, 1862, their first child was born, a daughter they named Julia.

In 1862, Nast drew half a dozen Civil War sketches for *Harper's Weekly*. In his patriotic drawings, he depicted the righteousness of the Union cause and the wickedness of the enemy. These sketches were followed by two sentimental Christmas drawings that touched the hearts of his readers.

The drawings appeared in the January 3, 1863, issue of *Harper's Weekly*. On the cover of the magazine was a drawing entitled *Santa Claus in Camp*. In the picture, Santa Claus was wearing a fur coat patterned after the Stars and Stripes of the Union flag and was distributing gifts to Union troops. Because Santa was not wearing a coat patterned after the Confederate flag, the Stars and Bars, Nast was implying that the Confederate troops had been bad boys and would not be receiving gifts from Santa.

Placed inside the same magazine was another Nast drawing entitled *Christmas Eve 1862*. On one side of the page was a picture of a young wife

HARPER'S WEEKLY.

A
JOURNAL OF CIVILIZATION

VOL. VII.—No. 314.] NEW YORK, SATURDAY, JANUARY 3, 1863. [SINGLE COPIES SIX CENTS.
$2 50 PER YEAR IN ADVANCE.

Entered according to Act of Congress, in the Year 1862, by Harper & Brothers, in the Clerk's Office of the District Court for the Southern District of New York.

SANTA CLAUS IN CAMP.—[SEE PAGE 6.]

Nast loved Christmas, and helped create the image of Santa Claus that we know today. Santa Claus in Camp *was published on the cover of* Harper's Weekly *in January 1863.*

praying for her soldier husband. On the other side of the page was a picture of her husband resting near a campfire, looking at a photograph of his family. This drawing struck a sentimental chord with many readers of the magazine. Colonel John Beatty of the 3rd Ohio Volunteers wrote in his diary, "The picture . . . will bring tears to the eyes of many a poor fellow shivering over the campfire in this winter season."[10] Another colonel wrote to the *Harper's* office and said he cried when he unfolded it by the light of his campfire. "It was only a picture, but I couldn't help it."[11]

In 1863, Nast bought a house in Harlem on 125th Street near Fifth Avenue and built a large studio in the back of the lot. He also became a director of a well-known savings and loan bank, joined the Union League Club of New York City, a Republican men's club, and became a member of the 7th Regiment, a volunteer militia unit. The regiment was formed in 1847, and the members of the regiment developed their own rules, chose their own officers, supplied their own equipment, and designed their own uniforms.

Election of 1864

Re-election looked bleak for Abraham Lincoln at the beginning of 1864. Many Northerners blamed Lincoln for the lack of a Union victory in the war. Although the Republican party nominated him for re-election at its convention, Lincoln doubted he

could win. He wrote on August 23: "It seems exceeding probable that this administration will not be re-elected."[12] Andrew Johnson, a Southerner who supported the Union, was chosen as Lincoln's running mate in hopes of winning Southern votes.

At its nominating convention, the Democratic party adopted a resolution submitted by Clement Vallandigham, a lawyer from Ohio. Vallandigham's resolution called for the immediate end of the war and for the rebellious Southern states to be brought back into the Union at any cost. Vallandigham's supporters became known as Copperheads because they reminded loyal Unionists of poisonous snakes with copper-colored heads. This term was often used by Republicans to refer to Democrats who opposed the Lincoln administration.

The Democrats chose former Union General George B. McClellan as their candidate for president. Lincoln had fired McClellan as commander of the Union armies in November 1862. McClellan promised to end the war and to restore the Union. The Democrat's campaign slogan was "Mac Will Win the Union Back."[13]

As the election of 1864 approached, the tide of the war changed. The Union Army under the command of General William Tecumseh Sherman finally made its way to Atlanta, Georgia. After a long siege, the city surrendered.

After the victory in Atlanta, Nast drew one of his most influential drawings, *Compromise with*

the South—Dedicated to the Chicago Convention. The drawing was published in the September 8, 1864, issue of *Harper's Weekly.* Nast's drawing predicted what would happen if the Democratic Copperheads won the election of 1864. In the drawing, a defiant Southerner was shaking hands with a crippled Northern soldier over the grave of Northern heroes who had died "in a useless war."[14] Columbia, a woman who symbolizes liberty, is sorrowfully kneeling at the grave. In the background, an African-American family is once again wearing the chains of slavery. *Compromise with the South* was so well received that *Harper's* printed extra issues. The drawing was also used in a Republican campaign flyer and millions of copies were distributed.

Lincoln won the election of 1864. The following spring, on April 9, 1865, the Southern forces commanded by General Robert E. Lee surrendered to Union General Ulysses S. Grant at Appomattox Court House in Virginia. The Civil War was coming to an end.

During the Civil War, Nast drew nearly seventy drawings. He used his pen like a sword, and his goal at all times was to "hit the enemy between the eyes and knock him down."[15] His sketches helped shape the views of thousands of Americans about the war and resulted in such a strong outcry of patriotism that President Lincoln called Nast "our best recruiting sergeant. . . . His emblematic cartoons have never failed to arouse enthusiasm and patriotism,

HARPER'S WEEKLY.

JOURNAL OF CIVILIZATION.

VOL. VI.—No. 299.] NEW YORK, SATURDAY, SEPTEMBER 20, 1862. [SINGLE COPIES SIX CENTS. $2.50 PER YEAR IN ADVANCE.

Entered according to Act of Congress, in the Year 1862, by Harper & Brothers, in the Clerk's Office of the District Court for the Southern District of New York.

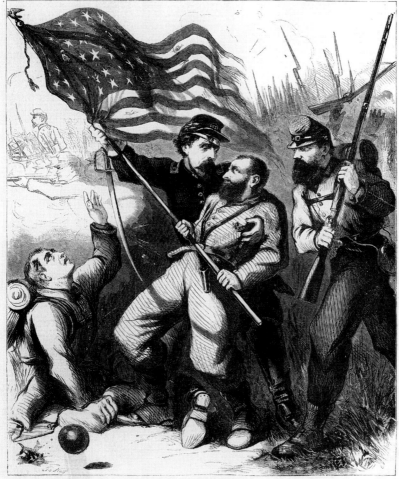

A GALLANT COLOR-BEARER.—[SEE NEXT PAGE.]

A Gallant Color Bearer *was one of the most famous of Nast's nearly seventy Civil War drawings.*

and have always seemed to come just when these articles were getting scarce."[16]

Five days after Lee's surrender, an assassin named John Wilkes Booth shot President Lincoln in the back of the head while he was attending a play at Ford's Theatre in Washington, D.C. Saddened by Lincoln's death, Nast drew a touching sketch entitled _Columbia Mourns_. It was published in _Harper's Weekly_ on April 29, 1865. In the drawing, Columbia has collapsed in tears before Lincoln's casket. In the background, a sailor and an infantryman are weeping.

5

THE ART OF CARICATURE

When the Civil War ended, Thomas Nast was twenty-five years old and had developed a national following. *Harper's Weekly* highly praised his artistic ability and predicted his continued success. The Nast family had grown. On April 28, 1865, his second child and namesake, Thomas, Jr., was born.

Becoming a Great Caricaturist

During the war, Nast tried to put too many pictures into one drawing and relied heavily on long, wordy captions. In time, his style matured. He developed the special skill of portraiture—being able to draw a remarkable likeness of an individual. He exhibited

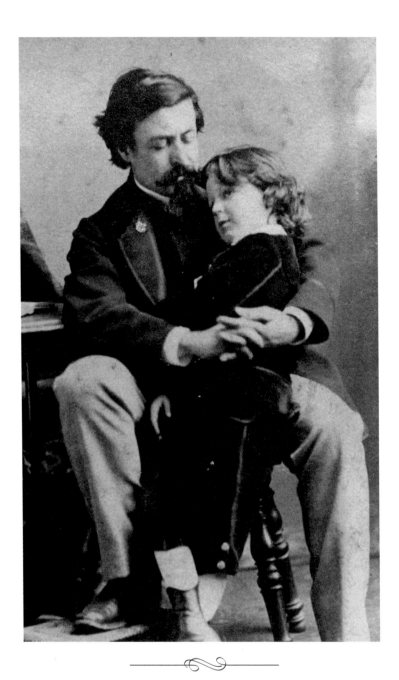

Family was very important to Thomas Nast. He is seen here with his son Thomas Nast, Jr.

his talent in 1865, when he won a contest sponsored by *Mrs. Grundy*, a short-lived weekly magazine that poked fun at the human vices and follies of the day. Nast won one hundred dollars, and his drawing was used to illustrate the first cover of the magazine.

In his drawing, the mythical Mrs. Grundy was standing on a stage facing an audience of a hundred prominent people, including Nast. The drawing was only six by eight inches. Nast must have used a magnifying glass to draw his characters. Each individual's head was only one eighth of an inch.

Nast's portraits eventually evolved into caricatures. A caricature is a drawing of a person in which the individual's peculiar features are exaggerated so as to appear ridiculous. In an article Nast wrote about creating caricatures, he explained how to exaggerate a subject's characteristics: "If a man has a long neck make it longer; if he is very tall, give him additional inches; if he is small and short, make him more so; if he is obese, he is to be credited with more notable rotundity of form."[1] Nast also added that a caricaturist had to be careful not to exaggerate too much. He felt that excessive exaggeration "prevents quick identification of the subject."[2]

In 1866, Nast drew sixty life-sized caricatures of prominent men and women. The caricatures were used as decorations at a Grand Masquerade Opera Ball given at the New York Academy of Music on April 5. Nast had the opportunity to observe the people he had drawn and noted that "every one of them

who was present appeared to think the caricatures excellent until he came to his own." Then their expressions changed greatly.[3] Later, eighteen of the drawings were featured in a double-page spread in *Harper's Weekly*. Because the art of photography had not yet been perfected, recognizable drawings of prominent people were in great demand.

The first president of the United States Nast drew in caricature was Andrew Johnson. Even though Johnson was a Southerner, he had been expected to come down hard on the South after the war.

Andrew Johnson

Andrew Johnson was originally a tailor by profession. His tailor shop in Greenville, Tennessee, became the favorite meeting place for local craftsmen and poor white farmers. Johnson, with his powerful voice and quick wit, led the group in their opposition to slaveholding plantation owners. Johnson's friends and neighbors recognized his leadership abilities. He was elected to the post of alderman (city councilman) in 1828, mayor in 1830, state representative in 1835 and 1839, state senator in 1841, United States congressman in 1843, governor of Tennessee in 1853, and United States senator in 1857. When Tennessee seceded from the Union on June 8, 1861, Johnson remained in the Senate and supported the Union. He became vice president in March 1865 and assumed the presidency when Abraham Lincoln was assassinated.

Instead, he surprised his Republican supporters and refused to punish the former Confederate States or force them to grant the right to vote to former African-American slaves. Nast, a Republican, thought Johnson was a dictator and traitor. He drew several derogatory cartoons of him.

Nast's direct attack on President Johnson led to a controversy with his editor at *Harper's Weekly*, George W. Curtis, who preferred a more subtle, indirect approach. Nast stood his ground. As far as he was concerned, an issue was either black or white. There was no gray or middle ground. Fletcher Harper, one of the owners of *Harper's Weekly*, saved the day by declaring that "there was room on the journal staff for men of differing ideas and methods."[4]

In 1867, Nast spent the majority of his time preparing a series of thirty-three historical paintings for an exhibit

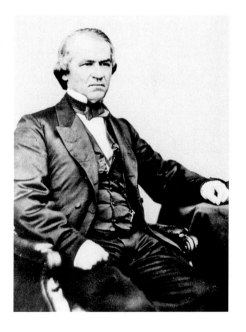

Andrew Johnson, who became president after Lincoln's assassination, was hated by many Republicans. They thought he was too easy on the former Confederates and did not push hard enough for civil rights for the former slaves.

called the Grand Caricaturama. The murals were the result of a year of research and two hundred sketches. Each mural was eight feet high and twelve feet wide. The exhibition opened in New York City on December 4, 1867, and the following March in Boston.

The murals were a moving panorama on stage and were presented by an actor and accompanied by music. The paintings covered such historical topics as the Declaration of Independence, states' rights, the emancipation of slaves, and Reconstruction of the Union. Although the theatrical presentation received good reviews, it failed to make a profit. Nast eventually abandoned the project and gave several of the murals to a house painter to use as drop cloths.[5]

"Match Him"

On July 2, 1868, Nast's second daughter, Sarah Edith, was born. Nast enjoyed his simple home life and having his children nearby. His wife, Sarah, often discussed his work with him. At times, when the right words would not come to him, she would make suggestions for the captions of his cartoons. She suggested the caption "Match Him" for the huge portrait of Ulysses S. Grant that Nast drew for the backdrop of the speaker's platform at the Republican nominating convention. At the convention, Grant was chosen as the Republican candidate for the presidency.

Grant won the election of 1868 by a narrow margin. He received only three hundred thousand more votes than the Democratic candidate, Horatio Seymour. It appears that the ballots in the South of five hundred thousand recently freed slaves swung the election in Grant's favor. After the election, Grant said, "two things elected me, the sword of Sheridan [a reference to Union troops in the South making sure that recently freed slaves were allowed to vote] and the pencil of Thomas Nast."[6] The following year, in April 1869, the Union League Club of New York City also honored Nast for his patriotism during the Civil War. They presented Nast, who was still a member of the club, with a silver vase.

6

THE TWEED RING

Thomas Nast had little tolerance for public officials who did not take the public good to heart. When his fellow board members of a well-known savings bank voted themselves salaries, Nast resigned. In his resignation letter, Nast wrote that he had always thought the savings and loan bank was a charitable institution and that the board members gave of their time without charge. He mentioned that the board had eloquently spoken of "gathering the crumbs of the poor," but that it appeared to him that, after they were gathered, they were putting the crumbs in their own pockets. Nast closed his letter with the remark that he did not care "to belong to a Savings Bank 'Ring.'"[1]

Members of the Tweed Ring

Shortly after resigning from the savings bank board of directors, Nast began his crusade to expose the Tweed Ring. The leader of the ring was William Marcy Tweed, a huge man who stood almost six feet tall and weighed three hundred pounds. Tweed had been a chair maker, saddler, bookkeeper, fireman, state congressman, and lawyer. With his commanding presence and charming ways, he soon came to the attention of the leaders of the Democratic party. In 1863, he became the leader of the Democratic party when he was elected to the post of Great Sachem of Tammany Hall. Tammany Hall was the Democratic party's headquarters in New York City. Through this position, Tweed seized control of the city's government. His associates began calling him "Boss."

The other three members of the Tweed Ring were Peter B. Sweeney, Richard B. Connolly, and A. Oakey Hall. Peter Sweeney was short with black eyes, a walrus mustache, and a full head of bushy black hair. Many observers felt Sweeney was the brains behind the ring. A cold man with few friends, Sweeney became the city's chamberlain in the fall of 1867. This was an important appointment. The city chamberlain "controlled the depositing of the city's funds in bank accounts."[2]

Born in Ireland, Richard Connolly was extremely popular with Irish immigrants. He was a large, portly man with a round clean-shaven face. He continually wore a stovepipe hat, even indoors, which

exaggerated his height. His neat penmanship and ability to keep track of vast sums of money made him a valuable member of the ring. His friends called him "Slippery Dick," and Tweed appointed him to the post of city controller.

The most colorful member of the ring was A. Oakey Hall. He was short and wiry, liked colorful clothes, and wore a different necktie and cuff links every day. His nickname was "The Elegant Oakey." He had been a successful newspaper reporter, lawyer, lobbyist, playwright, and actor. Hall married well and was a member of New York City's upper class. In 1868, he was elected mayor. His role "was to act as a liaison between the Ring and New York society."[3]

The ring truly had New York City under its thumb. Its members granted favors for a fee, awarded city jobs to their followers, and bought votes. The police, election officials, and even criminals were bribed by the ring

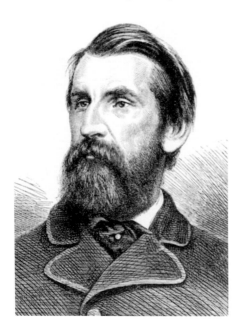

A. Oakey Hall, the mayor of New York City, was one of the most colorful members of the Tweed Ring.

to do its bidding. The city's advertising budget was used to muzzle and control the majority of New York's newspapers.

In 1867, the ring's power spread from city hall to the state capital when Tweed was elected state senator. Not only was Tweed a senator, but he also held executive positions in banks and railroads, as well as in gas, printing, and insurance companies. Tweed even planned to have one of his associates elected president of the United States.

Opposing the Tweed Ring

In 1868, along with Nast's drawings, *Harper's* began to publish anti-ring editorials. Tweed, unaccustomed to opposition, became irritated with all the attention *Harper's* was focusing on him and retaliated. "That's the last straw! . . . I'll show them damned publishers a trick!" he said.[4] Then he had the board of education "reject all Harper bids for school-books and destroy $50,000 worth of Harper books the city already had on hand. They were replaced by books

Shiny Hat Brigade
Twelve thousand of the ring's devoted followers were given city jobs. For this privilege, they were expected to return a percentage of their salaries to the ring. Because of the employees' fondness for wearing tall, sleek hats, they were called the Shiny Hat Brigade.

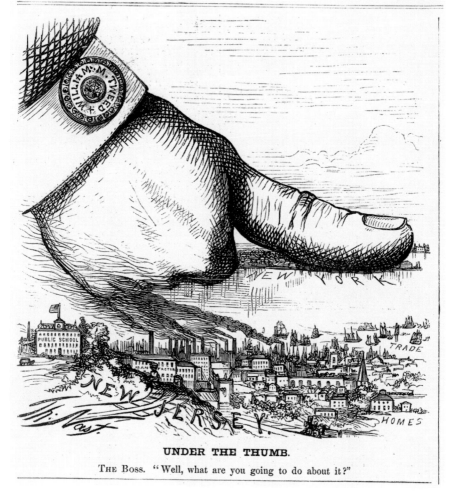

UNDER THE THUMB.

The Boss. "Well, what are you going to do about it?"

Nast drew Under the Thumb *to illustrate William "Boss" Tweed's control over New York City. In the caption, Nast quoted Tweed as saying, "Well, what are you going to do about it?"*

from the New York Printing Company, a corporation owned by the Tweed Ring."[5]

Financially, this was a heavy blow for *Harper's*. A meeting of its board of directors was called to discuss the situation. Several members of the board wanted to give in and end the crusade against the ring. Disgusted, Fletcher Harper got ready to leave the room and told his colleagues, "Gentlemen you know where I live. When you are ready to continue the fight against these scoundrels, send for me. Meantime, I shall find a way to continue it alone."[6] The other members of the board called Fletcher Harper back, and the crusade against Tweed continued.

The Times Joins the Crusade

On September 4, 1870, *The New York Times* joined Thomas Nast and *Harper's Weekly* in their crusade against the Tweed Ring. The two publications tried to focus on the specifics of the ring's corruption but had little proof to back them up. All they could accomplish was to point out that the ring members were "living too high and too well."[7]

Their campaign was aided by the tremendous display of wealth at the wedding of Tweed's daughter, Mary Amelia, in May 1871. Twenty-one-year-old Mary Amelia married Arthur Ambrose Maginnis, from a prominent Southern family. Their wedding chapel was crowded "with a richly dressed audience."[8] At the wedding, Tweed's wife wore diamonds in her ears, on her arms, around her neck, and even had

diamond buttons on her white satin shoes. The wedding reception was held in Tweed's mansion on the corner of Fifth Avenue and Forty-third Street. Tweed paid Delmonico's, a famous restaurant in New York City, thirteen thousand dollars to cater the affair. Since Tweed only received ten thousand dollars a year from his various municipal salaries, it was apparent that he was supplementing his income from other sources.

Proof of the Ring's Activities

Undeniable proof of the ring's source of wealth reached the desk of Louis Jennings, the editor of *The Times*, through an unusual route. In March 1871, the county auditor, James Watson, was killed in a sleighing accident. He was replaced by William Copeland, who secretly copied financial records that documented the ring's fraudulent disbursements. Copeland turned these documents over to his friend, Sheriff James O'Brien. The sheriff also had another city bookkeeper, Matthew J. O'Rourke, working for him as a spy. O'Rourke copied down financial information that documented the ring's outrageous overcharging and the kickbacks the ring received while outfitting and repairing the city's armories, where weapons and military equipment were stored.

At first, O'Brien tried to blackmail Tweed with the information, but Tweed refused to pay. O'Brien then went to see Louis Jennings.

"You and Nast *have had* a hard fight," O'Brien said to Jennings.

"Have still," Jennings replied.

"I said you have had it," repeated O'Brien. Then he handed Jennings a roll of papers he had taken from his pocket. "Here are the proofs of all your charges— exact transcriptions from Dick Connolly's books. . . ."[9] Jennings was so fascinated with the material he stayed up all night, reading the documents.

When the ring discovered that *The Times* had proof of its guilt, members offered George Jones, the publisher of *The Times*, a $5 million bribe. Jones refused the money and *The Times* published the information it had obtained about the city's armory expenditures. The headline on the July 8, 1871, article read: "GIGANTIC FRAUDS IN THE RENTAL OF ARMORIES."[10] Ten facilities, located mostly over old stables, had been rented by the city for eighty-five thousand dollars. Although these facilities had never been used, an additional $463,064 had been charged for repairing them. *The Times* boldly demanded that city officials disprove the information it had printed by producing their books for public inspection.

Orangeman Riot

A few days later, the ring was hit by another blow. Every year on July 12, an Orange Day parade was held in New York City. Members of the Orange Society, Protestant immigrants from Northern Ireland, sponsored the parade. The event was held on the anniversary of the Battle of Boyne in which

the Protestant king, William of Nassau, defeated the Catholic king, James II of England.

Many Irish Catholics living in New York City supported the Tweed Ring and objected to the parade. The year before, a riot had occurred during the parade and several people had been killed. Police predicted that there would be more trouble this year between Irish Catholics and Protestants. This put the ring in a difficult position. If it let the parade take place, it would have to protect the Orangemen and possibly take down the men whose votes had put its members in office.[11] Mayor Hall took the coward's way out and forbade the parade.

After a loud public outcry, New York Governor John Hoffman rescinded the mayor's order. He declared that "any and all bodies of men desiring to assemble and march in peaceable procession in this city tomorrow . . . will be permitted to do so. They will be protected to the fullest extent possible by the military and police authorities."[12]

Eighth Avenue was cleared on the day of the parade. At two o'clock in the afternoon, the parade began. Nast marched with his volunteer militia unit, the 7th Regiment of New York City. An observer later wrote:

> The bayonets of the military force designed to act as an escort could be seen flashing in the sun, as the troops with measured tread moved steadily forward. Crowds followed them on the sidewalks or hung from the windows and house-tops, while low curses could be heard on every side. . . .[13]

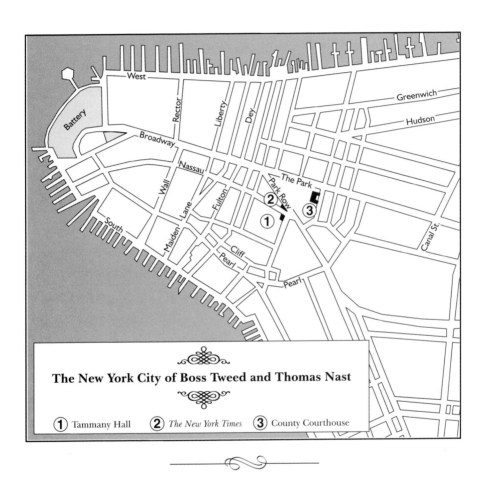

The New York City of Boss Tweed and Thomas Nast

(1) Tammany Hall (2) *The New York Times* (3) County Courthouse

This map of New York City, as it looked around 1851, shows some of the places associated with the Tweed Ring and Thomas Nast's fight to bring the ring down.

At Twenty-fourth Street, when the parade halted, a shot was fired, killing one of the soldiers escorting the Orangemen. His comrades panicked, and without orders, began firing into the crowds on the sidewalks. In a short time, two soldiers, a policeman, and forty-six civilians, including women and children, had been killed.

The public was outraged. One commentator declared that the victims of the riot should have the words "Murdered by the criminal management of Mayor A. Oakey Hall" written on their tombstones.[14]

Something That Will Not Blow Over

After the riots, Mayor Hall commented on the disclosure of the armory expenditures. He reportedly said, "even if there was anything to it, it would blow over before the next election."[15] Nast disagreed and drew a cartoon entitled *Something That Will Not Blow Over* that was published in *Harper's Weekly*. In the drawing, Tammany Hall has been blown up and Mayor Hall is hanging on for dear life to the remains of one side of the building. Below Hall, several Irish supporters are trying to revive Tweed. In the right-hand corner of the drawing, Peter Sweeney has found his hat and is quickly departing with what appears to be the ring's money in a suitcase labeled *Brains*.

On Saturday, July 22, 1871, the ring was hit by a third blow. *The Times* published the entire copy of the city controller's books that it had obtained from

Sheriff O'Brien. The front-page headline read: "The Secret Accounts: Proofs of Undoubted Frauds Brought to Light."[16] This information, printed in bold type and carefully tabulated, clearly illustrated that millions of dollars had been spent by city officials without benefiting the public. On July 29, *The Times* printed a special report on the armory and courthouse swindles in both English and German. Two hundred thousand copies of the report were quickly sold.

The most revealing information provided in the transcript was about the cost of constructing and furnishing the city's new courthouse. Forty chairs and three tables had cost the city $179,729.60. Other furniture items purchased from Ingersoll & Company had cost $204,564.63. A plasterer by the name of Andrew J. Garvey had been paid $2,870,464.06 for plastering walls over a nine-month period. So far, the courthouse had cost $11 million and was still not completed.[17]

In response to *The Times* articles, Nast drew two humorous drawings in which he posed what he called *Two Great Questions*. The drawings were published in the August 19, 1871, issue of *Harper's Weekly*. The first drawing was entitled *Who Is Ingersoll's CO?* In it, Horace Greeley, the publisher of the *New York Tribune*, is asking Tweed who Ingersoll & Company is. Tweed, with his numerous supporters hiding behind him, is pointing to himself, implying that the company is a front for the Tweed

Ring. The second drawing is entitled *Who Stole the People's Money?* In reply to the question posed in the cartoon's title, the ring and its supporters are standing in a circle, each pointing to another, claiming that the blame belongs to the person standing next to him.

Shortly after *The Times*'s disclosures, Nast began receiving threatening letters and noticed rough-looking characters hanging around his neighborhood. When his friend, the local police captain, was transferred to a different district, Nast decided to move his family out of Harlem across the Hudson River to Morristown, New Jersey. Morristown was a popular place for New Yorkers to spend the summer. Trains ran frequently from Morristown to Hoboken, which was a short ferry ride across the Hudson River to Manhattan. Nast returned daily to his Harlem studio to work. Because the ring could not intimidate Nast, it tried to bribe him. This made Nast even more resolved to see the ring behind bars.

Nast and Tweed Meet

One morning, Thomas Nast met William "Boss" Tweed face-to-face while driving in a carriage in Central Park. Nast tipped his hat to Tweed. Although Tweed had threatened to horsewhip Nast on sight, he returned the gesture and tipped his hat to Nast.

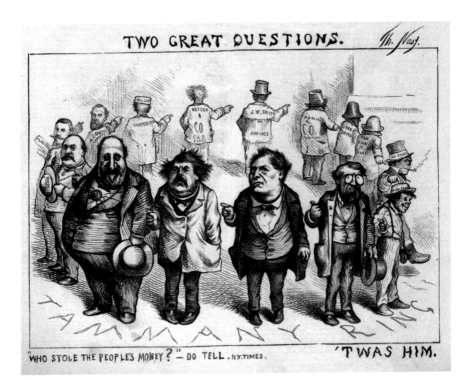

Tweed, Peter Sweeney, Richard Connolly, A. Oakey Hall, and their fellow conspirators are caricaturized by Nast as each passes the blame for corruption in New York on to the next person in line.

Photographer Mathew Brady captured this image of Thomas Nast in 1870.

Committee of Seventy

On September 4, 1871, a large public rally was held at Cooper Union to determine what to do. The rally was sponsored by a group of seventy prominent New Yorkers who called themselves the Committee of Seventy. The reformers' goal was to investigate corruption in the city government and to prosecute the guilty.

Three days later, Judge George S. Barnard, a former associate of the ring, granted a court order restraining Tweed and his associates from using public funds. On Saturday, September 9, a special committee appointed by the Committee of Seventy requested that Controller Richard Connolly produce certain vouchers for inspection the following Tuesday.

Oddly enough, before the controller's office opened on Monday morning, the vouchers had disappeared. A thief had cut a hole in the controller's office window and managed to take only the vouchers that the committee had requested to examine. The public was outraged. *The Times* pointedly asked in an editorial "why the city had spent $404,347.72 on safes and not given one to the Controller."[18]

Nast responded to this fiasco with a drawing entitled *The City Treasury*, which was printed in the October 14, 1871, issue of *Harper's Weekly*. On one side of the drawing, workmen are sorrowfully looking into a safe marked *New York Treasury* and

finding it full of debts. In the background, a woman is crying into her handkerchief. On the other side of the drawing, all four members of the Tweed Ring are seated at a table in a luxurious setting, toasting themselves with champagne glasses.

The Tweed Ring was voted out of public office in the municipal elections of 1871. Prior to the election, *Harper's* published a Nast cartoon that was proclaimed to be "one of the most powerful cartoons of all time."[19] The cartoon helped sway voters away from the ring's influence and the Democratic party. Entitled *The Tammany Tiger Loose—What Are You Going to Do About It?*, the cartoon showed the Tweed Ring sitting in a coliseum and watching as the Tammany tiger, which represented the Democratic party, destroyed Columbia, who represented the nation.

After the election, reformers brought criminal charges against all four members of the ring for stealing millions of dollars. Facing jail terms, Peter Sweeney and Richard Connolly left the country and never returned. After Mayor Hall finished his term of office, he was brought to trial three times, but he was never convicted.

Due to various technicalities, William "Boss" Tweed did not go to trial for almost two years. The six-day trial ended in a hung jury—the jurors could not agree whether Tweed were guilty. Ten months later, a new trial began. Tweed was found guilty, sentenced to thirteen years in prison, and fined

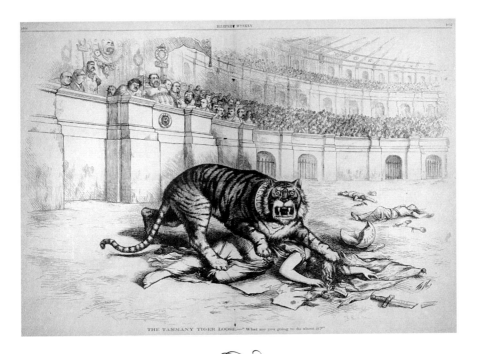

The Tammany Tiger Loose—What Are You Going to Do About It? *was one of Nast's most powerful drawings. After its publication, the Tweed Ring was voted out of office.*

$12,500. It was a small fine, considering the millions of dollars he had stolen. Tweed still had friends in high places. After a year in jail, his conviction was overturned. Nast was still determined to see Tweed convicted. He continued to draw cartoons portraying Tweed as a thief.

7

THE PRINCE
OF POLITICAL
CARTOONISTS

After the defeat of the Tweed Ring, Thomas Nast was a national hero. *The New York Times* called his cartoons the most powerful tools used against the ring. Even people who could not read had been able to understand what Nast was trying to say in his drawings.

Nearly every leading newspaper in the United States printed an editorial praising Nast. *Harper's Weekly* also benefited from Nast's popularity. During the crusade against the ring, *Harper's* circulation tripled from one hundred thousand readers to three hundred thousand. Many people wrote to *Harper's*, inquiring about Nast's previous work. Collectors started acquiring his drawings.

Villa Fontana

Nast decided to make Morristown, New Jersey, his permanent home. His family had grown once again. On December 4, 1871, Nast's fourth child, Mabel, was born. Four months later, Nast purchased a spacious two-story house on the corner of Macculloch Avenue and Miller Road for $21,250 from David Rockwell. Nast named his new home Villa Fontana after the beautiful homes he had seen in Italy.

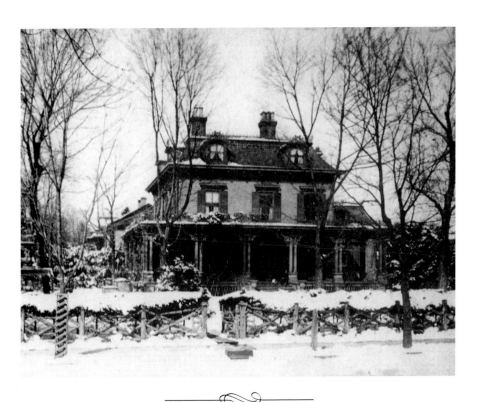

Villa Fontana, the house Nast purchased in Morristown, New Jersey.

In 1872, Nast's major concern was the re-election of President Ulysses S. Grant. Nast idolized Grant. He believed Grant was an honest soldier who had saved the Union during the Civil War. Rumors were circulating about corruption in Grant's administration. Many Democrats were clamoring for Nast to attack the president as he had "Boss" Tweed. Nast ignored the rumors. He believed the charges were simply malicious efforts to discredit the president. In his opinion, the Democrats would do or say "Anything to beat Grant!"[1]

The editors at *Harper's* shared Nast's opinion of Grant. In their editorials, they wrote that Southern Democrats, who were abusing Grant, could "not forgive his victory over the rebellion [Civil War]."[2] They added that the "greatest national disaster" would be "the restoration of the Democratic party to power."[3]

Corruption in the Grant Administration
Ulysses S. Grant graduated from West Point and became a professional soldier. He had never held a public office until he was elected president in 1868. Grant, a man of unquestionable integrity, was fiercely loyal to his friends and political supporters. Unfortunately, he placed his faith in a number of dishonest men, and his administration was plagued with one scandal after another, although he was not personally involved.

Trip to Washington, D.C.

In February, Nast went to Washington, D.C., to look over the political situation for himself. In a letter to his wife, Nast wrote that President Grant found out he was in the capital and sent word that he wanted to see him. Nast wrote, "I had a very pleasant chat with him, about everything in General, . . . I was there about an hour with him and when we got through he asked me to come and dine with him & his family at 5 P.M."[4]

Nast and Grant had a great deal in common. They were both family men who preferred the company of their wives and children to "official functions and public honors."[5] A friendship developed between the two men. Fred Grant, one of President Grant's sons, later noted that Nast and his father became extremely close.[6]

In another letter to Sarah a few days later, Nast wrote that he saw the president almost every day and that

> he is always very pleased to see me. It's funny how all the Senators are in a flutter about my being here and are all afraid that I will do them up [draw a cartoon of them]. . . . Darling, the *power* I have is terrible . . . it frightens me, but darling you will keep a good look out for me, and will not let me use this *Power* in a bad cause.[7]

Horace Greeley

The Democrats chose Horace Greeley, the editor and publisher of the *New York Tribune*, as their candidate

for president at their nominating convention in July 1872. Greeley had grown up in poverty. He had little formal schooling. His mother taught him to read at home. At the age of fourteen, he was apprenticed to a newspaper editor and learned the printing trade. Greeley was a self-educated man. He read everything he could get his hands on. In 1831, he moved to New York City. Ten years later, he established the *New York Tribune.*

Greeley was an excellent subject for a cartoonist. He had blue eyes and a moon-shaped face that was fringed with muttonchop whiskers, long sideburns that extended down the side of his face to his beard. He wore small steel-rimmed glasses, a tall white hat, a flowing white coat, and usually carried a green umbrella. He often looked as if he had slept in his clothes.

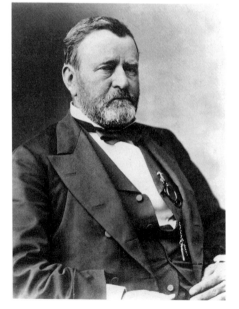

Consistency was not one of Horace Greeley's virtues. His opinions changed frequently. He also had little modesty,

In order to survey the political scene in 1872, Nast went to Washington, D.C. He had several meetings with Republican President Ulysses S. Grant (seen here). Grant went on to win re-election to the presidency.

which prompted one of his peers to say that he was "a self made man who worships his creator."[8]

Nast used Greeley's inconsistencies against him and portrayed him as foolish and overemotional. George William Curtis, the editor of *Harper's*, shared Nast's view and wrote that, if there were one quality he found indispensable for the president to have, it was "sound judgment."[9] Then he added that, "If there is one public man who is totally destitute of it, it is Horace Greeley."[10]

Grant's Victory

Largely through Nast's efforts and the support of *Harper's Weekly*, Grant was reelected to the presidency. He received 3,597,132 votes to Greeley's 2,834,125. So much criticism was focused on Greeley that he remarked that he sometimes wondered if "he was running for the presidency or the penitentiary."[11] After the

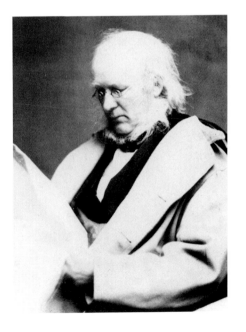

Editor of the New York Tribune, *Horace Greeley was very inconsistent in his political views. Thomas Nast used that weakness against Greeley, helping to defeat him in the 1872 presidential election.*

long campaign, the loss of the election, and the death of his wife, Greeley became ill. He died several weeks later on November 29, 1872. Many of Greeley's friends felt that the constant ridicule heaped upon him by Nast's drawings had caused his death.

Nast was highly praised for his role in reelecting Grant. The Republican National Committee sent him a letter of thanks. So did many public officials. Mark Twain, the famous author of *The Adventures of Tom Sawyer* and *Adventures of Huckleberry Finn*, also wrote Nast, thanking him for his endeavors:

> Nast, you more than any other man have won a prodigious victory for Grant—I mean, rather, for Civilization and Progress. Those pictures were simply marvelous, and if any man in the land has a right to hold his head up and be honestly proud of his share in this year's vast events, that man is unquestionably yourself.[12]

Harper's Exclusive

In 1873, the management at *Harper's* was fearful that another publication might try to recruit Nast. They proudly proclaimed that he was the "Prince of Caricaturists" and offered him an exclusive contract. The contract stipulated that Nast would be paid a yearly retainer of five thousand dollars whether or not he submitted any drawings to them. Also, for each picture he submitted, he would receive an additional one hundred fifty dollars.

Europe and Lecture Tour

Overwork and severe cramps in his right hand prompted Nast to take a vacation. He left for Europe in March. While traveling, he was approached by James Redpath of the Boston Lyceum. Redpath was eager to sign Nast up to do a lecture tour. Nast, shy by nature, at first refused. Finally, he agreed to undertake the tour.

During his first performance in Peabody, Massachusetts, on October 6, 1873, Nast suffered from such horrible stage fright that he insisted that Redpath sit on the stage with him. After the lecture, Nast wrote home to his wife: "It's done! The people seemed pleased, but I'm not. When I draw, all eyes are on me and the silence is dreadful. But when I get through, their pleasure is loud. . . . Write again soon to your traveling circus boy."[13] Nast toured for seven months and earned forty thousand dollars.

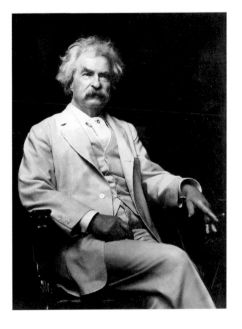

Author Mark Twain admired Nast's artistic abilities and forthright opinions. Twain visited the Nast family home in Morristown, New Jersey, after giving a lecture there.

Lyceum

The term *lyceum* was derived from the name of the school near Athens where the great philosopher Aristotle lectured to his students. A group of neighboring farmers formed the first lyceum in the United States in the early 1800s. Their goal was to share their knowledge with each other. After they exhausted their local pool of speakers, they began to import lecturers from other communities.

By 1850, there were nearly three thousand lyceums in the United States. To help the movement and recruitment of speakers for the lyceums, several speakers' bureaus were formed. James Redpath set up one of the oldest and most prominent speakers' bureaus in 1868.

Republican Elephant

Nast used an elephant as a symbol for the Republican political party for the first time in a drawing published in *Harper's Weekly* on November 7, 1874. Two unconnected events led to Nast's drawing. Many Democrats were worried that Grant would run for a third term. This had never occurred before and raised the cry of Caesarism. The term *Caesarism* refers to Julius Caesar, a Roman emperor, who had established himself as a military dictator in ancient Rome. In using the term to refer to Grant, people were implying that Grant was trying to establish himself as a military dictator. Many Republicans

were turning away from their party because they disliked the Grant administration.

The second event was a hoax masterminded by the *New York Herald*, a Democratic newspaper. The *Herald* published a story that the animals in the zoo had escaped and were roaming Central Park, searching for prey. The story was totally untrue and was meant to be a joke. Nast combined these two events into a cartoon in which a foolish elephant, labeled the *Republican Vote*, was being frightened away from doing his job by a bunch of hysterical jungle animals. This was Nast's reply to what he considered the phony scare of Caesarism. Nast believed that Grant would keep his word and not run for a third term as president.

The Republicans fared badly in the congressional elections of 1874. The Republican party lost control of the House of Representatives in Washington, D.C. Nast used the elephant for a second time to represent the Republican vote in a drawing. In his drawing, an elephant is caught in a trap, showing the way Republicans had been deceived and swayed from their normal allegiance by the idea of Grant's Caesarism. Nast wrote under his drawing: "Caught in a Trap. The result of a third-term hoax."[14]

"Boss" Tweed Escapes

In 1874, due to the efforts of New York Governor Samuel Tilden, a law was passed giving the attorney general of New York the power to bring a civil suit

against "Boss" Tweed. The civil suit was an attempt by the state to recover the money Tweed had stolen. Tweed was charged in a $6 million lawsuit, and bail was set at $3 million.

Tweed was arrested again and placed in Ludlow Street Prison. At Ludlow, he was treated like a prince and allowed a great deal of liberty. He went for morning rides in his coach with a prison guard acting as his footman. In the evening, he was permitted to dine with his family with a bailiff acting as his butler.

On December 4, 1875, Tweed arrived at his home for dinner and went upstairs to visit his wife. While his guard was preoccupied, Tweed sneaked out of his house and escaped. For several months, he hid in New Jersey and New York. In April, he obtained a passport under the name of John Secor and sailed to Cuba. He arrived in Santiago de Cuba on June 9, 1876. A month and a half later, he left Cuba and sailed to Vigo, Spain, arriving on September 6.

Cuban authorities detected Tweed's movements and informed United States authorities that he had left Cuba for Spain. No photographs of Tweed were available, so the American minister in Madrid sent a copy of _Harper's Weekly_ containing one of Nast's drawings of Tweed to Spanish authorities. In the drawing, Tweed is holding what appeared to be two children by the scruff of the neck. The Spanish police used the drawing to identify Tweed. They

could not read English and assumed that Tweed was a kidnapper. Ironically, this was one crime Tweed never committed.

Tweed was arrested and extradited from Spain. He was transported home aboard the U.S.S. *Franklin*, a United States frigate, on September 26, 1876, and arrived in New York on November 23. Once again, he was confined to Ludlow Street Prison.

Centennial Exposition

In 1876, the United States held a huge celebration called the Centennial Exposition in Philadelphia to commemorate the one-hundredth anniversary of the signing of the Declaration of Independence. The exposition was held in Philadelphia's Fairmount Park. Nearly fifty foreign countries and twenty-six states contributed exhibits. Nast and his family attended the exposition, and while there, purchased an Italian fountain, an elaborate staircase, a rustic cedar fence, and a gazebo for their home.

Election of 1876

In 1876, the Republicans chose Rutherford B. Hayes, the governor of Ohio, as their candidate for president. The Democrats nominated New York Governor Samuel Tilden as their candidate. Tilden had been one of the reformers who had helped destroy the Tweed Ring. Nast did not trust Tilden and considered the Democratic party's pro-South

In Tweed-le-dee and Tilden-dum, *Nast was showing how William "Boss" Tweed spent time with small criminals while allowing major criminals to go unnoticed. The drawing helped Spanish officials identify and arrest Tweed.*

views dangerous. He felt that you should "vote as you shot."[15] In other words, if you fought for the Union, then you should vote for the Republican party, which saved the Union.

When the election returns were counted, Tilden won the popular vote by the small margin of 250,000 votes. He received 184 electoral votes to Hayes's 165. However, a candidate had to have 185 electoral votes to win the election. Both parties claimed twenty electoral votes from three Southern states and Oregon. A great deal of political maneuvering took place. While this was happening, Nast drew a humorous cartoon of himself sharpening his pencil in order to get ready to go to work. The drawing was entitled *No Rest for the Wicked—Sentenced to More Hard Labor.*

A special commission was appointed by Congress to settle the issue. They gave all twenty disputed electoral votes to Hayes. The Democrats were outraged. Finally, a compromise was worked out. In return for winning the election, Hayes promised to withdraw the last federal troops who were observing Reconstruction, to push funding through Congress to rebuild the war-torn South, and to appoint one Southerner to his Cabinet. The purpose of the compromise was to return political control of their states to the Southern Democrats. Nast could not endorse the compromise and wanted to break away from Hayes. *Harper's* chose to remain loyal to the Republican party, and Nast was pressured

HARPER'S WEEKLY.

JOURNAL OF CIVILIZATION.

VOL. XX.—No. 1040.] NEW YORK, SATURDAY, DECEMBER 2, 1876. [WITH A SUPPLEMENT. PRICE TEN CENTS.

Entered according to Act of Congress, in the Year 1876, by Harper & Brothers, in the Office of the Librarian of Congress, at Washington.

1876.

AMERICANS!

REMEMBER, WE ARE NOT UPON THE EVE OF A REVO-
LUTION.

REMEMBER, GENERAL GRANT *IS* PRESIDENT OF THE
UNITED STATES.

REMEMBER THAT BUCHANAN *IS NOT* PRESIDENT OF
THE UNITED STATES.

REMEMBER, THERE ARE NO TRAITORS IN THE CAB-
INET NOW.

REMEMBER THAT IT IS THE COUNTRY WHICH IS AT
STAKE, AND NOT GAMBLERS' POOLS.

REMEMBER THAT WE DON'T SCARE WORTH A CENT,
AND IF HAYES IS ELECTED, HE *SHALL* BE INAUGU-
RATED.

"The 'Solid South' has gone for TILDEN and HENDRICKS, and, by the
God of battles, they shall be inaugurated!"—*Evansville (Ind.) Courier*
(*Dem.*).

" To see and dare
and decide; to be a
fixed pillar in the wel-
ter of uncertainty."

THOS. CARLYLE.

[That's U. S. GRANT.]

MONUMENT
IN
HONOR(?)
OF
ADAMS
FALL.
BOSTON.
MASS.

REFORM IS
NECESSARY
AND WE
MUST WATCH THAT
IT IS CARRIED OUT IN GOOD
FAITH.

THE
$OLID
$OUTH
MUST BE
WATCHED
OR THEY
WILL PREY

NO REST FOR THE WICKED—SENTENCED TO MORE HARD LABOR.

Nast drew this caricature of himself entitled No Rest for the
Wicked—Sentenced to More Hard Labor. *It reflected his feelings
on his need to continue to work to fight political corruption.*

Uncle Sam

During the War of 1812, Samuel Wilson owned a meat slaughtering and packinghouse in Troy, New York. Wilson had a contract to supply meat to United States troops. He shipped his meat in barrels marked "U.S.," which stood for United States. This abbreviation was uncommon at the time, and people wanted to know what it meant. They were jokingly told that "U.S." stood for Uncle Sam. This nickname became popular, and in time, Uncle Sam, dressed in a suit decorated with stars and stripes, came to represent the nation.

to continue to support Hayes. Nast responded by drawing a cartoon of himself being held down in a chair by Uncle Sam, who is saying: "Our artist must keep cool, and sit down, and see how it works." In the top left-hand corner of the drawing is a sign that reads: "Watch and Pray . . . Stand back and Give the President's Policy a Chance."[16] Nast took a wait-and-see attitude, but eventually he lost patience and drew a sequel to this cartoon. In it, the bottom is dropping out of the policy chair as Uncle Sam flees from the scene.

8

DIFFICULT TIMES

In 1877, Nast lost his strongest advocate. On May 29, Fletcher Harper, the last surviving Harper brother, died. For fifteen years, Fletcher Harper had been Nast's champion and firmest supporter. After his death, Nast felt pressure to "bring his opinions into harmony" with George W. Curtis, the editor of *Harper's Weekly*.[1] Curtis felt that the political cartoons that appeared in *Harper's* should support and complement the editorials that appeared in the publication. Nast stubbornly refused to conform. Consequently, Curtis began to reject those of Nast's drawings that did not conform to his opinions. This angered Nast and he responded by drawing fewer cartoons.

Nast's absence from the pages of *Harper's Weekly* did not go unnoticed. *Harper's* received numerous letters demanding that Nast express his opinions about the current administration. The situation came to a head when Roscoe Conkling, a New York Republican senator, criticized Curtis in a speech. He referred to *Harper's Weekly* as the journal that had been made famous "by the pencil of Thomas Nast!"[2] The truth hit home. Within a few days, Nast was back at work again and able to express his opinions freely.

The *National Republican* commented on Nast's return to the pages of *Harper's Weekly*. They said that there was "a fly on the chariot wheel" and the fly was called Curtis. Then they added that they had "feared that the fly had become the charioteer. We are glad to see that we were mistaken. Nast is at work again. Shoo! Fly!"[3]

Champion of the Army and Navy

For many years, Nast had been the champion of the United States military forces. He opposed the cutting of military budgets in peacetime and often depicted American fighting men as skeletons in his drawings to call attention to the fact that they were poorly paid and lacked appropriate supplies. His efforts won him the respect of both the army and the navy.

Soldiers and sailors all over the country donated twenty-five cents to a fund to purchase a suitable

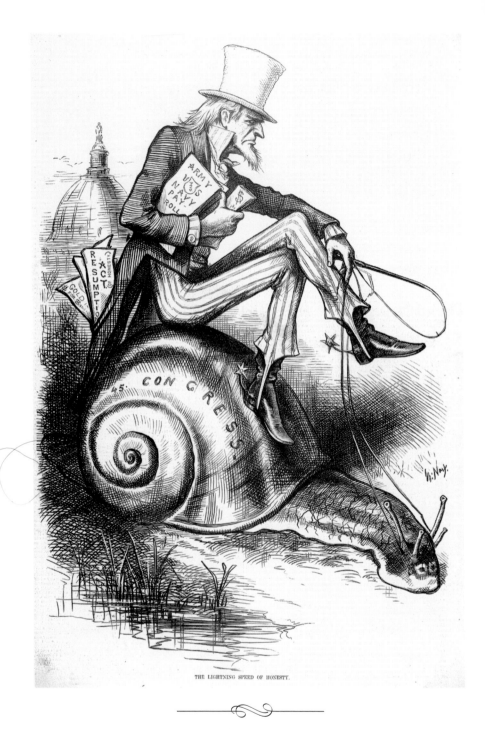

THE LIGHTNING SPEED OF HONESTY.

In The Lightning Speed of Honesty, *Nast wanted to illustrate the slow speed with which Congress dealt with appropriations for the military.*

tribute to their champion. On February 15, 1879, they presented Nast with a large silver vase shaped like a canteen. On one side of the canteen was an image of Columbia (who represented the United States) presenting Nast with a medal. On the other side was an inscription stating that thirty-five hundred officers and enlisted men in the United States Army and Navy had contributed to make the vase possible.

Chinese Exclusion

In the spring of 1879, Republican Senator James G. Blaine's advocacy for Chinese exclusion from the United States angered Nast. Twelve thousand Chinese immigrants had come to the United States to help build the transcontinental railroad after the Civil War. When the railroad was completed, many of the immigrants decided to stay in the United States. The Chinese worked for low wages. This angered many Americans, who felt the Chinese were taking jobs away from them. Blaine wanted to prevent more cheap Chinese labor from entering the United States.

Nast saw the Chinese immigrant as "a man and brother," and believed every person had a right to work and own property, no matter what his or her race was.[4] He drew an insightful cartoon of an American Indian and a Chinese man talking while reading a billboard that read "Prohibit Chinese Immigration."[5] In the caption of the drawing, the

Indian says to the Chinese man, "Pale face 'fraid [afraid] you crowd him out, as he did me."[6]

A Paper of His Own

On August 28, 1879, the Nasts' fifth child, a boy named Cyril, was born. The following Christmas, Nast drew a picture of Santa Claus bending over the new baby's crib for the family's Christmas card. The baby in the picture resembled Cyril, and Santa Claus looked a great deal like his proud father.

In December 1879, Nast drew the first cartoon in which he used both the elephant to represent the Republican party and the donkey to represent the Democratic party. The drawing was entitled _Stranger Things Have Happened_. The caption under the drawing read: "Hold on, and you may walk over the sluggish animal up there." Nast used the drawing as a warning. He was implying that, if the Democrats held on, they might be able to overthrow the Republicans.

In 1880, Nast was forty years old and at the height of his popularity. He longed for total editorial freedom and dreamed of establishing a paper of his own. He wanted to be able to "do battle for those social and political reforms which seemed to him so needful in the city and nation of his adoption."[7] He was a wealthy man with an estate valued at one hundred thousand dollars, but that was not enough capital to start a new publication. In order to achieve his goal, he began investing his savings recklessly.

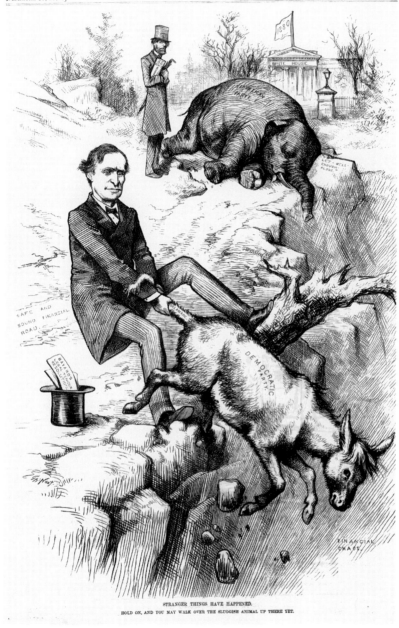

STRANGER THINGS HAVE HAPPENED.
HOLD ON, AND YOU MAY WALK OVER THE SLUGGISH ANIMAL UP THERE YET.

Nast used the elephant and donkey together for the first time to represent the Republican and Democratic parties in his cartoon Stranger Things Have Happened.

The Election of 1880

In 1880, the Republican party chose James A. Garfield as its candidate for president. Garfield was a big, athletic man who had been a successful professor, college president, Civil War general, and United States congressman. Nast supported his political party but had reservations about Garfield because of his supposed involvement in the Crédit Mobilier Scandal that came to light during the Grant administration.

Nast's situation became even more complicated when the Democratic party chose Winfield S. Hancock, another former Civil War general, as its candidate. Hancock was one of Nast's heroes and a close friend. When questioned about their friendship, Nast stated that he was fond of Hancock as a man, but not of his political party.

Nast submitted a drawing showing the various factions of the Democratic party surrendering to brave General Hancock. _Harper's_ rejected the drawing and Nast's relationship with his publisher was once again strained. A compromise was reached. Nast would stick to the issues and not be required to include Garfield in his cartoons. This was a difficult arrangement for both parties. In time, _Harper's_ management became dissatisfied with the arrangement and hired other cartoonists to contribute to the publication. The newcomers' work was not well received by the public. The press began to comment that Nast was not being permitted to express his opinions freely any longer.[8]

Crédit Mobilier Scandal

In 1862 and 1864, the federal government passed the Pacific Railroad Acts, which awarded a company called Union Pacific a large number of loans and land grants to construct a transcontinental railroad. Union Pacific contracted with a company called Crédit Mobilier to construct the railroads and paid unreasonably high bills submitted to them for the construction of the railroad. Union Pacific owned Crédit Mobilier and profited greatly from the overcharging.

During the campaign of 1880, *Harper's* adopted a new method for reproducing drawings in the publication. Throughout Nast's career, he had drawn his pictures with a soft pencil on the surface of hard wooden blocks. The blocks were then hand engraved, soaked in ink, and printed directly on the page. Nast became the undisputed master of this technique. The new photochemical process required Nast to draw his cartoons with a pen on paper. It took time for Nast to adapt to drawing his cartoons on paper. At first, his pen line appeared thin and delicate compared with the heavy and firm lines of his pencil drawings on wooden blocks.

Garfield won the election of 1880, but he was assassinated a few months after he took office. On July 2, 1881, Garfield was getting ready to board a

train when Charles J. Guiteau fired two shots at him. Guiteau held a grudge against Garfield for not appointing him to the post of United States consul to Paris. One of the bullets lodged in Garfield's back. Surgeons could not locate the bullet to remove it. Garfield lingered for eighty days and then died. After Garfield's death, Vice President Chester A. Arthur became president.

Grant and Ward Company

In early 1883, Nast sold his property in Harlem for thirty thousand dollars and invested the money in the firm of Grant and Ward. The firm was composed of Ulysses S. Grant, Jr. (one of the former president's sons), and Ferdinand Ward, whom many considered a financial genius. The firm supplied money for carrying out railroad contracts. Because the railroad business was booming in the United Sates, investors in the Grant and Ward firm expected to make large profits. Former President Grant had already invested one hundred thousand dollars in the firm.

The dividends that Nast received from his investment were so high that he even considered ending his contract with _Harper's Weekly_. It came as a great shock to him in May 1884 when Grant and Ward failed. The firm had been using Grant's name to inspire confidence. But it had been fraudulent from the beginning. Ferdinand Ward had made a habit of using new investors' money to cover the dividends paid to old investors. Nast lost all his

savings. He realized that his dream of owning a paper of his own might never materialize.

Home Life

Nast's studio was located upstairs on the second floor in Villa Fontana. He liked to have his family around him while he worked. Sometimes, Sarah would sit by the fireplace and sew as her husband worked. The Nast children came and went as they pleased. Nast did not care how much noise they made. His dogs, two Irish greyhounds, often stretched out and slept on the studio floor.

In one section of Nast's studio sat a large cylinder-top desk where he did a great deal of his work. The desk contained a gallery of photographs of "kings and queens, priests and popes, lords and generals, actors and actresses and persons of every walk of life."[9] Nast enjoyed collecting photographs "of persons whose faces pleased him."[10]

Nast also enjoyed cooking and set up a cooking school in his home for his daughter Julia and twelve of her friends. The group, called the Young Maiden's Cooking Association, had a party after each class, and consumed what they had prepared. Nast also drew the cover sketch for the Morristown community cookbook.

Mugwump Revolt of 1884

Nast was hit by another blow in 1884 when he realized that he could not support James Blaine, his

party's candidate for president. Nast did not trust Blaine and had announced that he would not support him "even if the Democrats should nominate the Devil."[11] Nast felt that Blaine had used his post as speaker of the House of Representatives for his own personal gain. After the Republican nominating convention, the board of directors of _Harper's Weekly_ met and declared that they would not support Blaine, either. For once, Nast was in complete agreement with them.

The defection of _Harper's_ and Nast from the Republican party was a serious blow. The Republican press considered _Harper's_ editor George W. Curtis and Nast traitors. One publication called _Judge_ published a poem about Nast's defection:

> _Poor, poor T. Nast_
> _Thy day is past—_
> _Thy bolt is shot, thy die is cast—_
> _Thy pencil point_
> _Is out of joint—_
> _Thy pictures lately disappoint._[12]

The Democrats skipped over the devil and nominated Grover Cleveland as their candidate for president. Cleveland was a big man with a good sense of humor who had been a successful lawyer, sheriff, mayor, and governor of New York. He was the kind of leader Nast could support. Many other influential Republicans felt the same way. They were nicknamed Mugwumps because they chose to support Cleveland instead of their party's candidate.

Grover Cleveland won the election of 1884 by one of the narrowest margins in United States history. He was the first Democrat elected to the office of president of the United States since 1856. With Cleveland's victory, Nast had successfully supported six presidential candidates.

However, Nast's break with the Republican party cost him mightily. He lost the support of many influential Republicans and friends. His losses were greater than the number of new supporters he found in the Democratic party. *Harper's* also suffered. At the beginning of the campaign, it had estimated its losses to be around fifty thousand dollars. In actuality, its losses were far more. In order to avoid a complete financial disaster, they became concerned about profits and could no longer afford Nast's outspoken opinions.

Departure from *Harper's Weekly*

In 1886, at the age of forty-six, Nast ended his association with *Harper's Weekly* when his contract expired after twenty-nine years. *Harper's* paid his retainer for one more year. Then Nast found it necessary to go back to the dreaded lecture platform. Nast disliked being on the stage by himself. To avoid this situation, he invited Walter Pelham, a famous English actor, to join him. The plan was for Pelham to ask Nast questions while Nast drew. The stage was set to look like an artist's studio with a large easel in the center.

Nast's twenty-one-year-old son, Thomas, Jr., acted as his father's press agent and general manager. The tour started in Morristown, New Jersey, and the group traveled west until they reached Portland, Oregon. Newspaper reviewers across the country repeatedly commented on the speed with which Nast drew from the lecture platform. The *New York Evening Post* reported that Nast "drew with astonishing rapidity large cartoons in crayon—houses, ships, faces, and elaborate caricatures, making almost all the changes of expression of which the human face is capable as rapidly as his assistant could describe them. . . ."[13]

One part of the program that particularly pleased audiences was when Nast drew a picture that made

Mark Twain Visits Nast

On Thanksgiving Eve in 1887, Mark Twain, the famous author and lecturer, visited Nast at his home in Morristown, New Jersey. Twain was on a lecture tour and had stopped in Morristown to do a reading. After his performance, Twain spent the night with the Nast family. When his host retired for the evening, Twain decided that the clocks in Nast's home annoyed him, so he got up and turned them off. Consequently, the whole family, servants and all, overslept. When accused of his "crime," Twain replied that the clocks had all been overworked and would feel better after a night's rest.[14]

no sense and then turned it upside down to reveal Niagara Falls. The show ended with Pelham attempting to draw a picture. Nast would step in and turn the muddle into a portrait of himself carrying a candle and wearing a nightcap on his head. It was Nast's way of saying good night to the audience.

Nast's tour was not as financially successful as he had hoped. His support of Grover Cleveland and the Democratic party adversely affected the size of his audiences. Several communities canceled after his tour began. When his health started to fail, Nast canceled his remaining engagements and returned home.

For the next few years, Nast worked on preparing a book of his Christmas drawings. He also drew political cartoons for the *New York Daily Graphic*. In 1888, he supported the re-election of Grover Cleveland and received a small amount of financial support from the Democratic National Committee. Cleveland lost to the Republican candidate, Benjamin Harrison. This was the first time Nast had backed a losing candidate.

9

THE MAN
WHO LOVED
SANTA CLAUS

No matter where he was or what he was doing, Thomas Nast always stopped to celebrate Christmas. It was his favorite holiday and he loved Santa Claus. Each year, armloads of gifts arrived at the Nast home on Christmas Eve. Before they went to bed, Nast's children hung their stockings from the fireplace mantel in their father's studio. On Christmas morning, they awoke to "a multitude of paper dolls—marvelously big and elaborate . . . arranged in processions and cavalcades . . . that marched in and about" their large gifts, which were sitting on the fireplace hearth.[1]

Nast's drawings of Santa Claus were inspired by Clement Moore's poem, "An Account of a Visit

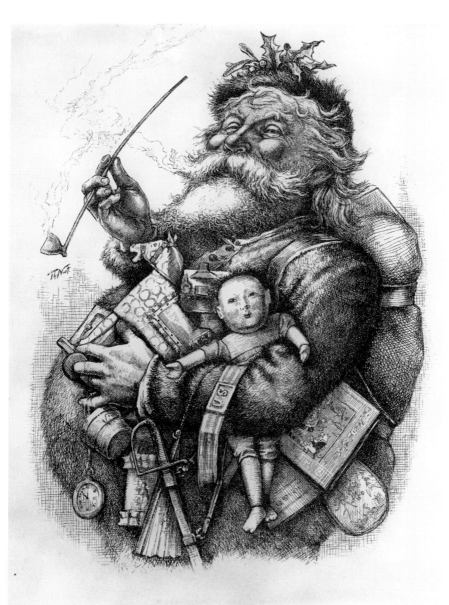

MERRY OLD SANTA CLAUS.

Nast loved Santa Claus, and in his drawings, he perfected the American version of the jolly old soul.

from St. Nicholas." Moore, a biblical scholar at the Episcopal seminary in New York City, wrote the poem for his own children in 1822 as a Christmas present. The poem was first published a year later in the *New York Troy Sentinel* and began with the famous words, " 'Twas the night before Christmas, when all through the house / Not a creature was stirring—not even a mouse."[2]

As Moore described in his poem, Nast portrayed Santa Claus in his drawings as a "jolly, round-bellied, white-bearded, fur-clad embodiment of good cheer."[3] Nast also drew Santa riding around on Christmas Eve, distributing toys to good little girls and boys in a sleigh pulled by eight magical reindeer—Dasher, Dancer, Prancer, Vixen, Comet, Cupid, Donner, and Blitzen.

To Moore's Santa Claus, Nast added a red suit trimmed in white fur and a workshop at the North Pole.[4] The North Pole, located an equal distance from the majority of the countries in the Northern Hemisphere, was an isolated place where Santa Claus could work without interruption. Nast drew Santa Claus watching children through his telescope from his workshop at the North Pole to see if they were being naughty or nice. Then he showed Santa Claus documenting their behavior in his account book. Nast also originated the idea that children could send Santa Claus mail at the North Pole and that he read all of their letters.

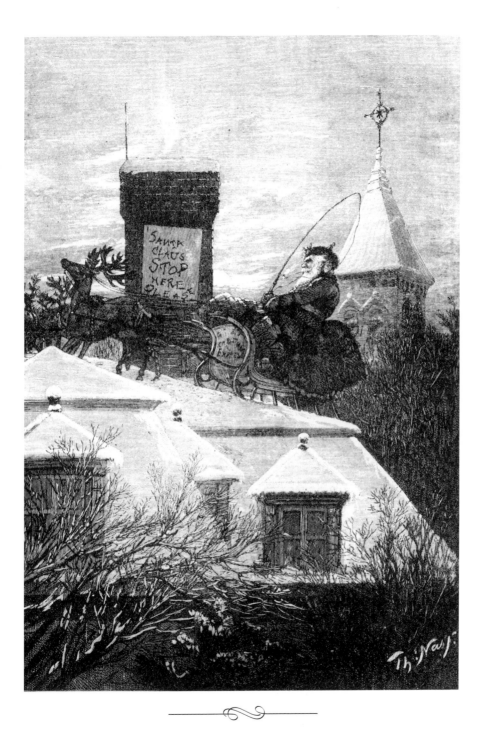

Nast's drawing Christmas Station *was inspired by Clement Moore's poem "An Account of a Visit from St. Nicholas."*

Christmas Flirtation

In one drawing entitled *Christmas Flirtation*, Nast drew his daughter Julia standing in front of a fireplace mantel below a sprig of mistletoe covered with berries. In England, it was a custom for boys to pluck a berry from the mistletoe every time they kissed a girl. When all the berries were gone, the privilege of kissing ended. Evidently, Nast was implying that Julia did not want the privilege of kissing to end too soon.

In 1890, just in time for the Christmas season, Harper and Brothers published Nast's book of Christmas drawings entitled *Christmas Drawings for the Human Race*. The book featured drawings that had previously appeared in *Harper's Weekly* from 1863 to 1886 and new drawings Nast created just for the book. In his new drawings, Nast used his five children as models and scenes from his Morristown home.

LATER YEARS

Afterward completing his book of Christmas drawings, Nast freelanced for various publications in New York and Chicago. He worked for *America, Time, The Illustrated American, Once-A-Week,* and *The Chicago Inter-Ocean.* With each publication his work was short-lived. He would either lose favor with the publication's editorial staff or the publication would go out of business.

Nast's Weekly

In March 1892, Nast began working as an editor and contributor to the *New York Gazette.* The publishers of the *Gazette* guaranteed Nast complete freedom to express his opinions. Unfortunately, the paper

was struggling for survival. Within five months, Nast became their main creditor. During the summer of 1892, the owners of the *Gazette* turned their publication over to Nast as payment for the money they owed him. By default, Nast finally had a paper of his own.

Nast renamed the publication *Nast's Weekly*, mortgaged his home to get enough capital to run the publication, and appointed his son Thomas Nast, Jr., as the publisher. The first issue of *Nast's Weekly* was published on September 17, 1892. Nast tried unsuccessfully to obtain financial backers for his paper. After five months, he shut the paper down, which left him heavily in debt.

New Career

In 1894, Nast traveled to Europe in hopes of finding work. He was unable to find a job as an illustrator, but several friends commissioned him to do paintings for them. While in London, Herman H. Kohlsaat, the former owner of *Inter-Ocean*, a Chicago publication, commissioned Nast to do a painting of Robert E. Lee's surrender to Ulysses S. Grant at Appomattox at the end of the Civil War. When Nast returned from Europe, he worked for several months on the painting and finished it on April 9, 1895, the thirtieth anniversary of the event. Kohlsaat donated the painting, entitled *Peace in the Union*, to the public library in Galena, Illinois, where Ulysses S. Grant had lived after the war.

Also, while in Europe, Henry Irving, a famous Shakespearean actor, commissioned Nast to do a painting of William Shakespeare. In July 1895, Nast wrote to Irving explaining his plan for the painting. He intended to draw a sculptured bust of Shakespeare in the room where he was born with the spirits of Comedy and Tragedy approaching the poet from either side to present him with a crown of laurels (high honors). Irving wholeheartedly agreed with

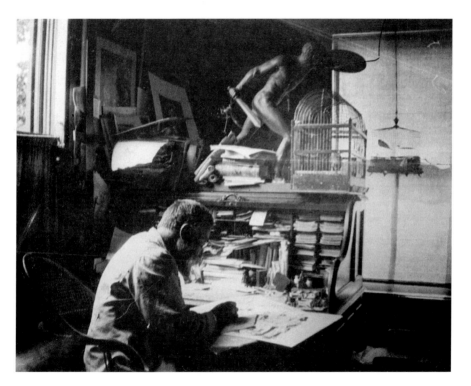

Nast spent a great deal of time in his studio, working on new ideas. This photo was taken in 1895, at the time when Nast went back to historical drawings.

his idea, and Nast began working on *The Immortal Light of Genius*. Irving donated the painting, completed on April 23, 1896, Shakespeare's birthday, to the William Winter Memorial on Staten Island.

In 1899, Nast received a commission from his childhood friend William L. Keese to do a third painting. Both Nast and Keese admired William E. Burton, who had been a popular actor on the New York stage when they were young. Keese hired Nast to do a painting of Burton in his memorable role as a character known as Toodles. Keese donated the painting to the Players Club in New York City, where both Keese and Nast were members. The Players Club was established in 1888 for men active in the theater, literature, and the arts.

While working on his historical paintings, Nast was the subject of feature articles in newspapers and

Volunteer Fireman

Nast was an honorary member of the Independent Hose Company of the Morristown Fire Department. Their firehouse was located a short distance from his home, and he liked to socialize with the firemen. In 1897, in honor of the hundredth anniversary of the fire company, Nast painted a forty-by-sixty-inch caricature of himself dressed as a fireman. The inscription on the painting read "Hurrah Boys. We are 100 years old." The firemen hung the painting over the bar in the second-floor lounge of their firehouse.

magazines that alluded to him as a figure of the past. Letters were even sent to *Harper's Weekly*, referring to him as the late Thomas Nast. Sometimes he would reply with a small drawing of himself and the words: "I still live."[1]

Grandson's Remembrances

In 1898, Nast had five grandchildren. His oldest grandson, Thomas Nast St. Hill, recalled that Nast in his later years was "always impeccably dressed" and "very distinguished looking with his gray hair."[2] Nast liked to take his grandson on adventures, or sprees as he called them, into New York City. He took him to see Buffalo Bill's Wild West Show to see Annie Oakley shooting, and to the Players Club. St. Hill's most treasured souvenirs of his relationship with his grandfather were the sketches Nast sent him of their times together.

St. Hill also remembered watching his grandfather work in his home studio:

> I recall particularly the three-foot-high bronze statue of "The Gladiator" above his rolltop desk and the mockingbird in a cage close by. . . . The studio was on the second floor and as the mockingbird heard its master's footsteps ascending the stairs it would whistle to him and receive a whistle in reply. The bird had quite a repertoire and always responded to the attention paid to him by repeating the sounds he heard. When the artist was busy and had not taken notice of his feathered friend for some time, it would pick up a piece of gravel from the bottom of the cage and throw it at him.[3]

Consul General to Ecuador

Nast's indebtedness greatly troubled him. In 1902, President Theodore Roosevelt offered him the post of consul general in Ecuador. A consul is an official appointed by his or her government to live in a foreign country and look after his or her country's interests. Desperate for funds, Nast gratefully accepted. The position paid a yearly stipend of four thousand dollars, which seemed like a windfall to the artist.

The consulate office was located in Guayaquil, the principal port in Ecuador. Sanitary conditions were poor in Ecuador and yellow fever was common. Yellow fever was a deadly infectious tropical disease. Many of Nast's friends asked him what he was going to do in the "God-forsaken place?"[4] Nast replied, with his typical humor, that he was going there to find out how to pronounce the name of the place.[5]

On July 1, 1902, Nast departed from New York on a steamer headed for Ecuador. After he arrived in Guayaquil, he wrote regularly to his family at home:

August 12, 1902
Mice, rats, bats, mosquitoes, fleas, spiders, dirt all thrive. Water is scarce I haven't had a real bath yet. There is not enough to fill a tub.[6]

September 21, 1902
You say my poor old mockingbird misses me. I am very sorry. I do miss him, poor fellow, and his mocking sounds.[7]

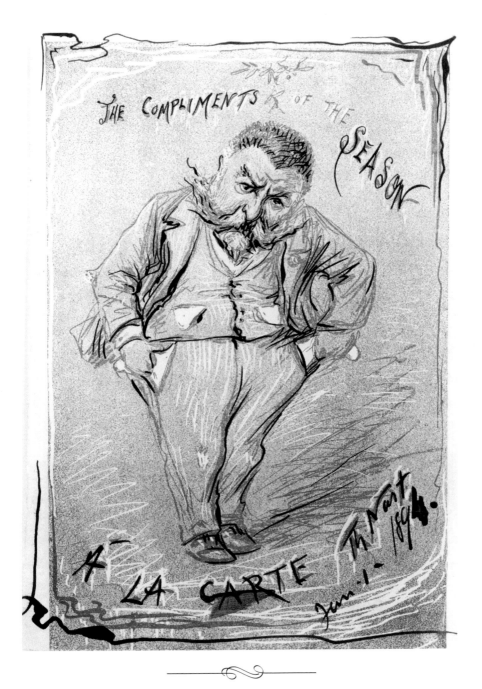

In this self-portrait, Nast poked fun at himself by showing his empty pockets as a result of unwise investments.

October 13, 1902

Every day two to four cases of yellow fever. Nearly all fatal.[8]

October 20, 1902

Well, Well, what with painting, when I am able to do it (it dries so very slowly) and what with the Encyclopaedia Britannica, I manage to kill time. I have been reading it steadily and enjoy it very much.[9]

Nast had sent part of his stipend home and wrote:

November 21, 1902

You say the money arrived safely and it is in the bank. Just think of it? Bills paid and money, real money in the bank again. . . .[10]

Nast wrote his last letter home on Sunday, November 30. The following day, he became ill. A few days later, doctors diagnosed his illness as yellow fever. On December 7, 1902, he died. Five hours after his death, Nast was buried in a Guayaquil cemetery. His coffin was wrapped in an American flag and an official of the British government recited a prayer at his graveside.

11

EPILOGUE

A letter dated December 11, 1902, from the State Department in Washington, D.C., informed Sarah Nast of her husband's death. The letter simply quoted the telegram that had been received from Guayaquil: "Nast died today of yellow fever."[1]

On the rolltop desk in his studio, Nast's family found a foreboding sketch he had made before his departure to Ecuador. The sketch was a drawing of Nast's pen and pencil tied together with a black ribbon. Evidently, Nast had a premonition that he might never use them again.

The New York Times published Nast's obituary on its front page. The obituary stated: "It was in . . . political caricature that Nast's star shone brightest."[2]

Harper's Weekly also published a tribute to its former special artist, calling him the "Father of American Caricature."[3]

Due to financial difficulties, Sarah Nast was forced to auction her husband's collection of books, correspondence, photographs, engravings, and a large number of his original drawings. The Merwin-Clayton Sales Company held the auction in New York City on April 2 and 3, 1906.

In the forward to the auction catalog, Albert Bigelow Paine, Nast's biographer, wrote:

> Thomas Nast . . . needs no introduction to the public. . . . Born in Landau, Germany in 1840, he came with his parents as a child of six to New York City, and within twenty years had become a national figure . . . through the magic power of his pencil, which was destined to engrave his name in the nation's history.[4]

Nast's remains were brought back to the United States in 1906. He was reburied in Woodlawn Cemetery in the Bronx, New York. Twenty-six years later, Sarah Nast died at the age of ninety-two and was buried beside her husband.[5]

In 1956, in memory of Thomas Nast, the United States Department of State placed a plaque in the barracks where Nast had been born in Landau, Germany. The plaque was given as a "gift to the German people in friendship and in memory of Thomas Nast."[6] On December 7, 1977, the seventy-fifth anniversary of Nast's death, Landau held a two-day festival in his memory. German and

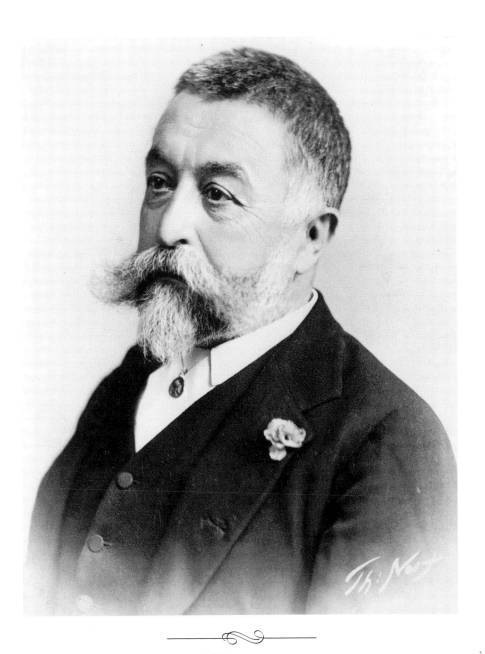

Thomas Nast is still remembered for his drawings, which continue to inspire and amuse Americans long after his death.

Nast Memorabilia
Villa Fontana, Nast's home in Morristown, New Jersey, is listed in the National Register of Historical Places. A plaque has been placed in front of the house, designating it as a National Historic Landmark. Macculloch Hall Historical Museum, across the street from Villa Fontana, has a large collection of Thomas Nast's engravings, photographs, and other Nast memorabilia.

American officials joined together while "Bands played, speeches were made and wreaths were laid" in Nast's honor.[7]

Legacy

Nast's legacy to future generations includes the symbols he made popular that are still recognized today: Uncle Sam, the Democratic donkey, the Republican elephant, and Santa Claus. When Santa Claus appears each year, American children would label him an imposter if he did not look like the Santa Claus portrayed in Nast's Christmas drawings.

Harper's Weekly summarized Nast's achievements best when it wrote in its final tribute to him that he was a patriot, and that, even though he was not born an American, he "worked and died a true lover of this country and a stalwart [valiant] warrior in her behalf."[8]

CHRONOLOGY

1840—Born in Landau, Germany, on September 27.

1846—Immigrates to United States.

1854—Attends drawing classes taught by Theodore Kaufmann.

1855—Enters the National Academy of Design.

1856—Joins the staff of *Frank Leslie's Illustrated.*

1859—Leaves *Frank Leslie's*; Freelances for *Harper's Weekly, Sunday Courier, Comic Monthly,* and *Yankee Notions*; Begins working for the *New York Illustrated News.*

1860—Goes to England to cover the prizefight between John Heenan and Thomas Sayers in February; Travels to Italy in June to cover Giuseppe Garibaldi's fight to free his country from Austrian and Spanish domination.

1861—Returns to the United States on February 1; Becomes engaged to Sarah Edwards; Covers Abraham Lincoln's inauguration in Washington, D.C., on March 4; Civil War begins in April; Marries Sarah Edwards on September 26.

1862—Joins staff of *Harper's Weekly* magazine; Daughter Julia born on July 1.

1863—*Harper's Weekly* publishes Nast's drawings entitled *Santa Claus in Camp* and *Christmas Eve* on January 3; Buys property in Harlem.

1864—Nast's drawing *Compromise with the South* is credited with helping reelect President Abraham Lincoln.

1865—George W. Curtis becomes editor of *Harper's Weekly*; Confederate troops surrender on April 9; President Lincoln is assassinated on April 14; Son Thomas Nast, Jr., is born on April 28.

1867—The Grand Caricaturama presented in New York and Boston.

1868—Daughter Sarah Edith born on July 2; General Ulysses S. Grant elected president with Nast's aid.

1869—Presented with silver vase from the Union League Club of New York City; Begins crusade against the Tweed Ring.

1870—*The New York Times* joins Nast and *Harper's* in their crusade against the Tweed Ring; Uses donkey to represent the Democratic party in a drawing for the first time.

1871—Moves family to Morristown, New Jersey; Tweed Ring voted out of public office.

1872—Buys home in Morristown; Campaigns for the re-election of President Grant.

1873—Vacations in Europe; Signs exclusive contract with *Harper's Weekly*; Lecture tour across the United States from October to April.

1874—Uses Republican elephant as a symbol to represent the Republican party.

1879—Presented with a silver army canteen from officers and enlisted men in the army and navy; Son Cyril born on August 29.

1880—*Harper's* adopts a new method for reproducing drawings in their publication.

1883—Invests savings in Grant & Ward Company.

1884—Grant & Ward Company fails in May.

1887—Nast resigns from *Harper's Weekly*.

1890—Publishes *Christmas Drawings for the Human Race*.

1892—Takes over the *New York Gazette* and renames it *Nast's Weekly*.

1893—*Nast's Weekly* fails.

1894—Due to difficulty in finding work as a cartoonist, Nast returns to painting historical subjects.

1902—Appointed consul general to Guayaquil, Ecuador; Dies of yellow fever and is buried in Guayaquil on December 7.

1906—Body is returned to United States and reburied at Woodland Cemetery in the Bronx, New York.

CHAPTER NOTES

Chapter 1. The Crusade

1. Joy Hakim, *Reconstruction & Reform* (New York: Oxford University Press, 1994), p. 95.

2. Oliver E. Allen, *The Tiger: The Rise and Fall of Tammany Hall* (New York: Addison-Wesley Publishing Co., 1993), p. 125.

3. Judith Freeman Clark, *America's Gilded Age: An Eyewitness to History* (New York: Facts on File, 1992), p. 36.

4. Allen, p. 103.

5. Croswell Bowen, *The Elegant Oakey* (New York: Oxford University Press, 1956), p. 50.

6. Allen, p. 125.

7. Ibid.

Chapter 2. Young Artist

1. Alice Abell Caulkins, *Thomas Nast & the Glorious Cause* (Morristown, N.J.: Macculloch Hall Historical Museum, 1996), p. 2.

2. Albert B. Paine, *Thomas Nast: His Period and His Pictures* (New York: Chelsea House, 1980), p. 12.

3. Ibid., p. 18.

4. Ibid.

5. Ibid., p. 19

Chapter 3. Learning His Trade

1. Albert B. Paine, *Thomas Nast: His Period and His Pictures* (New York: Chelsea House, 1980), p. 22.

2. Ibid.

3. Ibid., p. 32.

4. Ibid., p. 33.

5. J. Chal Vinson, *Thomas Nast: Political Cartoonist* (Athens: University of Georgia Press, 1967), p. 3.

6. Draper Hill, *Tommy on Top* (Memphis, Tenn.: The Egyptians, 1976), p. 91.

7. Vinson, p. 3.

8. Paine, p. 37.

9. Ibid., p. 44.

10. Hill, p. 95.

11. Ibid.

12. Ibid.

13. Paine, p. 51.

14. Ibid., p. 67.

15. Thomas Nast St. Hill, *Thomas Nast's Christmas Drawings for the Human Race* (New York: Harper & Row, Publishers, 1971), p. 4.

16. Geoffrey C. Ward, *The Civil War: An Illustrated History* (New York: Alfred A. Knopf, 1994), p. 12.

Chapter 4. Civil War Artist

1. Russell Freedman, *Lincoln: A Photobiography* (New York: Clarion Books, 1986), p. 62.

2. Ibid.

3. Freedman, p. 70.

4. Albert B. Paine, *Thomas Nast: His Period and His Pictures* (New York: Chelsea House, 1980), p. 75.

5. Ibid.

6. Ibid., p. 76.

7. Ibid.

8. W. Fletcher Thompson, Jr., *The Image of War: The Pictorial Reporting of the American Civil War* (New York: Thomas Yoseloff, 1959), pp. 75–76.

9. Paine, p. 82.

10. Thompson, pp. 90–91.

11. Ibid., p. 91.

12. J. Chal Vinson, *Thomas Nast: Political Cartoonist* (Athens: University of Georgia Press, 1967), p. 7.

13. Ibid.

14. Paine, p. 98.

15. Vinson, p. 5.

16. Ibid.

Chapter 5. The Art of Caricature

1. Thomas Nast, "Caricatures and Caricatured," *Journal of the Thomas Nast Society*, vol. 6, no. 1, 1992, p. 53.

2. Ibid.

3. Ibid., p. 55.

4. J. Chal Vinson, *Thomas Nast: Political Cartoonist* (Athens: University of Georgia Press, 1967), p. 12.

5. *The New York Times*, "Where One of America's Sharpest Political Wits Found Refuge, and a Home," March 17, 1996.

6. Morton Keller, *The Art and Politics of Thomas Nast* (New York: Oxford University Press, 1968), p. 45.

Chapter 6. The Tweed Ring

1. Albert B. Paine, *Thomas Nast: His Period and His Pictures* (New York: Chelsea House, 1980), p. 138.

2. Oliver E. Allen, *The Tiger: The Rise and Fall of Tammany Hall* (New York: Addison-Wesley Publishing Co., 1993), p. 100.

3. Alexander B. Callow, Jr., *The Tweed Ring* (New York: Oxford University Press, 1966), p. 37.

4. Croswell Bowen, *The Elegant Oakey* (New York: Oxford University Press, 1956), p. 80.

5. Ibid., pp. 80–81.

6. J. Chal Vinson, *Thomas Nast: Political Cartoonist* (Athens: University of Georgia Press, 1967), p. 17.

7. Callow, p. 252.

8. Ibid., p. 250.

9. Bowen, p. 84.

10. Allen, p. 123.

11. Bowen, p. 89.

12. Denis Tilden Lynch, *Boss Tweed: The Story of a Grim Generation* (New York: Blue Ribbon Books, 1927), p. 367.

13. Bowen, p. 93.

14. Lynch, pp. 368, 369.

15. "The Week," *The Nation*, August 3, 1871, p. 65.

16. Callow, p. 260.

17. Paine, pp. 174, 175–176.

18. Callow, p. 271.

19. Thomas Nast, *Thomas Nast Cartoons and Illustrations* (New York: Dover Publications, Inc., 1974), p. 19.

Chapter 7. The Prince of Political Cartoonists

1. J. Chal Vinson, *Thomas Nast: Political Cartoonist* (Athens: University of Georgia Press, 1967), p. 23.

2. Ibid.

3. Ibid.

4. Wendy Wick Reaves, "Thomas Nast and the President," *The American Art Journal*, vol. 19, no. 1, 1987, p. 62.

5. Ibid., p. 65.

6. "Thomas Nast and U. S. Grant," *Ulysses S. Grant Homepage*, August 27, 1997, <http://www.mscomm/~ulysses/page136.html> (December 31, 1999).

7. Reaves, p. 62.

8. Vinson, p. 24.

9. Albert B. Paine, *Thomas Nast: His Period and His Pictures* (New York: Chelsea House, 1980), p. 237.

10. Ibid.

11. Allen Nevins, "Horace Greeley," *Horace Greeley Page*, July 23, 1996, <http://www.tulane.edu/~latner/Greeley.html> (December 31, 1999).

12. Lin Salamo and Harriet E. Smith, eds., *Mark Twain Letters 1872–1873* (Berkeley: University of California Press, 1997), p. 249.

13. Paine, p. 284.

14. Ibid., p. 301.

15. Vinson, p. 29.

16. Alton Ketchum, *Uncle Sam: The Man and the Legend* (New York: Farrar Straus & Giroux, 1959), p. 63.

Chapter 8. Difficult Times

1. J. Chal Vinson, *Thomas Nast: Political Cartoonist* (Athens: University of Georgia Press, 1967), p. 30.

2. William Murrell, *A History of American Graphic Humor* (New York: Cooper Square Publishers, Inc., 1967), p. 63.

3. Albert B. Paine, *Thomas Nast: His Period and His Pictures* (New York: Chelsea House, 1980), p. 370.

4. Ibid., p. 413.

5. Morton Keller, *The Art and Politics of Thomas Nast* (New York: Oxford University Press, 1968), plate 150.

6. Ibid.

7. Paine, p. 418.

8. Ibid., p. 434.

9. "Thomas Nast at Home," *Iron Era*, Dover, New Jersey, June 7, 1884. (Vertical file: Joint Free Public Library of Morristown and Morris Township.)

10. Ibid.

11. Vinson, p. 36.

12. Ibid.

13. Betsy G. Miller, "The Nast-Pelham Lecture Tour," *Journal of the Thomas Nast Society*, vol. 10, no. 1, 1996, p. 2.

14. Paine, p. 512.

Chapter 9. The Man Who Loved Santa Claus

1. Penne L. Restad, *Christmas in America* (New York: Oxford University Press, 1995), p. 147.

2. Thomas Nast, *Thomas Nast's Christmas Drawings for the Human Race* (New York: Dover Publications, Inc., 1978), p. vi.

3. Ibid.

4. Restad, p. 147.

Chapter 10. Later Years

1. J. Chal Vinson, *Thomas Nast: Political Cartoonist* (Athens: University of Georgia Press, 1967), p. 39.

2. Thomas Nast St. Hill, *Thomas Nast's Christmas Drawings for the Human Race* (New York: Harper & Row, Publishers, 1971), p. 104.

3. Ibid., p. 108.

4. Albert B. Paine, *Thomas Nast: His Period and His Pictures* (New York: Chelsea House, 1980), p. 559.

5. Ibid.

6. St. Hill, p. 119.

7. Ibid., p. 120.

8. Ibid., p. 121.

9. Ibid.

10. Ibid.

Chapter 11. Epilogue

1. Richard C. Simon, "The Last Days of Thomas Nast," *Journal of the Thomas Nast Society*, vol. 6, no. 1, 1992, pp. 56–63.

2. "Death of Thomas Nast," *Journal of the Thomas Nast Society*, vol. 6, no. 1, 1992, pp. 64–65.

3. "The Great American Cartoonist," *Journal of the Thomas Nast Society*, vol. 6, no. 1, 1992, pp. 66–67.

4. "Catalogue of the Library, Correspondence and Original Cartoons of the Late Thomas Nast," *Journal of the Thomas Nast Society*, vol. 10, no. 1, 1996, p. 79.

5. Thomas Nast St. Hill, *Thomas Nast's Christmas Drawings for the Human Race* (New York: Harper & Row, Publishers, 1971), p. 114.

6. Thomas Nast, *Thomas Nast's Christmas Drawings* (New York: Dover Publications, Inc., 1978), p. viii.

7. Ibid.

8. "The Great American Cartoonist," p. 67.

GLOSSARY

allegiance—Faithfulness to a cause.

bailiff—An assistant to a sheriff.

canteen—A small container to carry water.

chariot—A two-wheeled carriage pulled by horses.

charioteer—The person who drives a chariot.

coconspirators—Associates who secretly plan to do something unlawful or wrong.

cohorts—Associates or followers.

coliseum—A large building or stadium for games, contests, or sporting events.

defection—A falling away from loyalty, duty, or belief.

dividends—Money earned as profit by a company and divided among the owners or stockholders of a company.

follies—Foolish or silly acts.

freelance—Sell work to anyone who will buy it.

horsecar—A car pulled by horses that carries passengers on city streets.

infantryman—A soldier who fights on foot.

league—An association of people united by common interests.

libel—A published statement or picture that could harm the reputation of the person about whom it is made.

lobbyist—A person who tries to influence members of a lawmaking body.

municipal—Having to do with the affairs of a city.

muzzle—To compel someone to keep quiet.

panorama—A picture unrolled one piece at a time and made to pass continuously before an audience.

political corruption—Dishonest, illegal, or immoral behavior on the part of elected officials.

retainer—A fee paid to secure services on a continuing basis.

saddler—Someone who makes saddles and other leather projects.

satire—The use of mockery, irony, or wit to attack or ridicule someone or something.

stovepipe hat—A tall black silk hat.

transcontinental—Crossing a continent.

vice—An evil, immoral, or wicked habit.

yellow fever—A dangerous and often fatal tropical disease transmitted by mosquitoes in which the skin turns slightly yellow.

FURTHER READING

Books

Freedman, Russell. *Lincoln: A Photobiography*. New York: Clarion Books, 1986.

Hakim, Joy. *Reconstruction & Reform*. New York: Oxford University Press, 1994.

Kent, Zachary. *The Civil War: "A House Divided."* Hillside, N.J.: Enslow Publishers, Inc., 1994.

Nast, Thomas. *Thomas Nast's Christmas Drawings*. New York: Dover Publications, Inc., 1978.

Paine, Albert B. *Thomas Nast: His Period and His Pictures*. New York: Chelsea House, 1980.

Pflueger, Lynda. *Mark Twain: Legendary Writer and Humorist*. Berkeley Heights, N.J.: Enslow Publishers, Inc., 1999.

Internet Addresses

Macculloch Hall Historical Museum. *Macculloch Hall*. n.d. <http://www.machall.org/>.

Nast Santas—The Greatest Santa Claus Web Site in the World! n.d. <http://www.nastsantas.com/>.

Ulysses S. Grant and Thomas Nast, Cartoonist. August 27, 1997. <http://mscomm.com/~ulysses/page136 .html>.

INDEX